IMAGES
of America

SAN BERNARDINO
CALIFORNIA

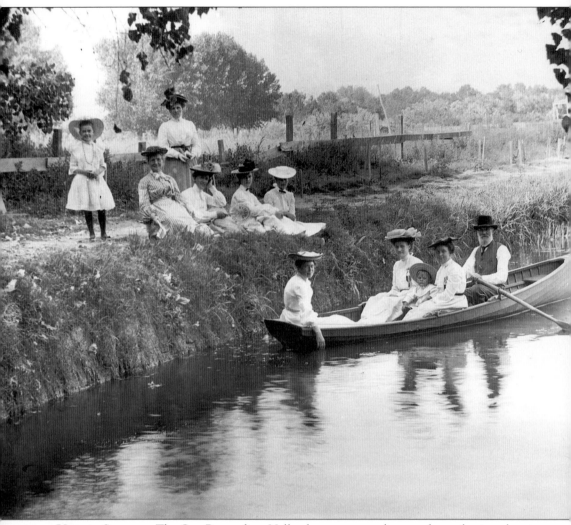

URBITA SPRINGS. The San Bernardino Valley has numerous hot geothermal mineral springs that spew up from under ground. Because of this natural phenomena, several hot springs resorts flourished during the early 1900s. This 1903 photo shows one of the most popular local retreats known as Urbita Springs. As you can see, there was also a natural lake there. Inland Center Mall marks the spot today. (Courtesy of author.)

IMAGES
of America

SAN BERNARDINO
CALIFORNIA

Nick Cataldo

ARCADIA

First Printed 2002.
Reprinted 2003, 2004.

Published by Arcadia Publishing,
an imprint of Tempus Publishing, Inc.
Charleston SC, Chicago, Portsmouth NH,
San Francisco

Printed in Great Britain.

Library of Congress Catalog Card Number: 2002110149

For all general information contact Arcadia Publishing at:
Telephone 843-853-2070
Fax 843-853-0044
E-Mail sales@arcadiapublishing.com

For customer service and orders:
Toll-Free 1-888-313-2665

Visit us on the internet at http://www.arcadiapublishing.com

CITY SEAL. This is the city seal for San Bernardino. Although historical research has indicated that a rancho that went by the name "San Bernardino" began in 1819 and only through undocumented references indicate the "founding" date to be 1810, the earlier year is used on the seal.

CONTENTS

ACKNOWLEDGMENTS

In putting this book together, I thought of the many people who have touched my life over the years. I would need an entire book in order to list all of them. Hoping that nobody feels left out, I can only acknowledge several of the wonderful people who inspired me to become fascinated with researching local history. I'd like to especially thank three friends who have since passed on: Fred Holladay, Russ McDonald, and the "historian's historian," Arda Haenszel; to John Swisher, who encouraged me to write this book; to Linda Puetz of the Norman Feldheym Library, who took time out from her work schedule in order to scan many of these photos; to docents in the library's California Room; and to those friends who loaned me photos for this publication. Most of all I wouldn't have been able to make this book happen if it weren't for my wonderful family for always encouraging and supporting me: my parents, John and Frances; my son, Jay; and especially to Linda, my loving wife of 16 years.

Thanks to you all!

INTRODUCTION

When Western history buffs think about the rip roaring "shoot 'em up" frontier towns of yesteryear, legendary mining camps and cow towns like Tombstone, Virginia City, and Dodge City usually come to mind.

What few people realize is that in Southern California, the City of San Bernardino was every bit of a "Wild West" town as those more glorified sites. Gambling halls, saloons, and "ladies of the night"—San Bernardino had it all!

When Mormon families from Salt Lake arrived in what was known as Rancho San Bernardino in 1851, the landlords of the area were fed up with the constant struggle to protect their horses from marauding Indians and American outlaws invading from the desert. The frustrated owners, headed by Don Antonio Maira Lugo, were eager to sell their land to the Mormons.

Shortly after the deal was made between the two parties, rumors surfaced regarding an Indian uprising from the Mojave Desert. A stockade—centered at today's San Bernardino County Court House—was soon built to help protect the recently arrived settlers.

Fortunately, no such uprising ever surfaced. Within a year, the fort was dismantled and the young fledging community rode a cohesive, law-abiding course for the next few years.

However, when Mormon president Brigham Young recalled his faithful back to Salt Lake in 1857 with strict orders to sell their property for whatever they could get, roughly 60 percent followed his command, leaving much of the leadership in the young community in disarray.

It was high anxiety time for the town's remaining residents as newcomers came to San Bernardino eager to buy land and a home for what often was not much more than a horse and wagon. Many of these new arrivals were not of the most gentile sort.

Before long, the corner of 3rd and "D" became infamously known as Whiskey Point, so named because it hosted saloons at each corner. Prostitution in San Bernardino became so notorious that below the city limits, "D" Street became known for its Red Light District.

Fortunately for San Bernardino, this lawless reputation was not destined to remain forever. Thanks to the intestinal fortitude of dedicated citizens like Ben Barton, John Brown, and Fred Perris, the town began playing a more positive role as an important gate city of Southern California.

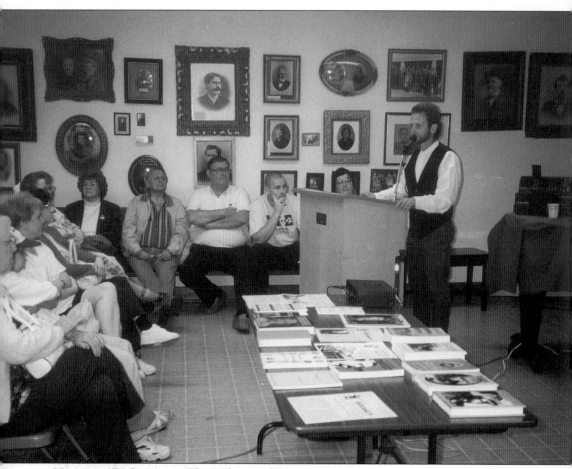

NICHOLAS R. CATALDO. The author is talking to a crowd of guests attending a San Bernardino Historical and Pioneer Society program about Old West legend, Wyatt Earp, his family, and the time the legendary family lived in the San Bernardino area.

One

THE FIRST SAN BERNARDINANS

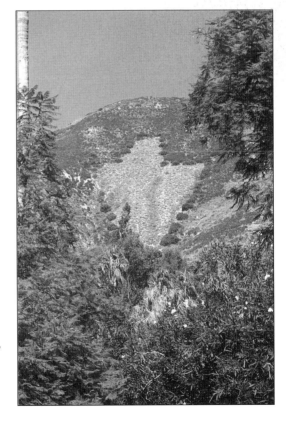

THE ARROWHEAD. Geologists say that this arrowhead-shaped formation looking down into San Bernardino is a natural phenomenon. It measures 1,376 feet long with a width (at its widest point) of 479 feet. The arrowhead was very important to the Indians of the San Bernardino Valley. There are several local Indian legends as to the origin of the arrowhead. One story tells of a flaming arrow leading the natives into the valley. Others reveal the belief that the unique formation represented battles between good and evil, or showed the way to good hunting grounds and to therapeutic hot springs. The arrowhead is the emblem for San Bernardino County. (Courtesy of Author)

MOHAVE TRAIL. Long before the coming of the White man, an ancient trade route stretched across the Mojave desert connecting the Mohave Indian villages on the Colorado River with the Pacific Coast. Part of this "Mohave Trail" approximated the current fire break that appears in this picture down the south slope of the mountain range above the San Bernardino outskirts community of Devore. (Courtesy of Author).

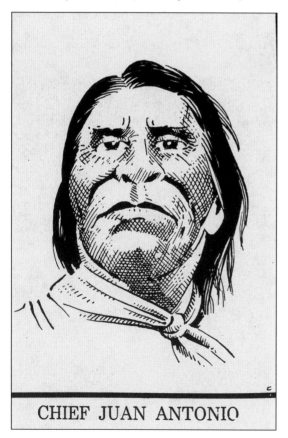

CHIEF JUAN ANTONIO

CHIEF JUAN ANTONIO. Chief Juan Antonio was a Cahuilla Indian chief who lived in the area of Twentynine Palms before moving into the San Bernardino Valley. He became a true friend of the early San Bernardino settlers, first in helping the Lugo family in the mid-1840s ward off horse thieves, and later helping the Mormon colonists who feared an all out "Indian uprising" from the desert tribes.

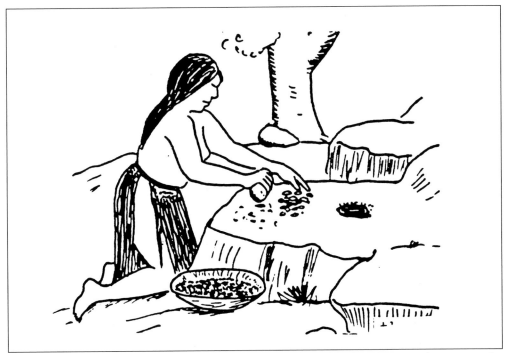

SERRANO INDIAN. The first people living in the vicinity of San Bernardino were the Yuhaviatam, or as the Spanish called them during the 1700s and early 1800s, Serrano (meaning Highlander). Because they were hunters and gatherers, they migrated with the seasons from the mountains to the floor of San Bernardino Valley.

LOUISA PINO, A SERRANO INDIAN. One of the families living at San Manuel Indian Reservation northeast of San Bernardino was the Pinos. Here you can see in this c. 1900 photo Louisa Pino grinding acorns near her home. (Courtesy of Pauline Murillo.)

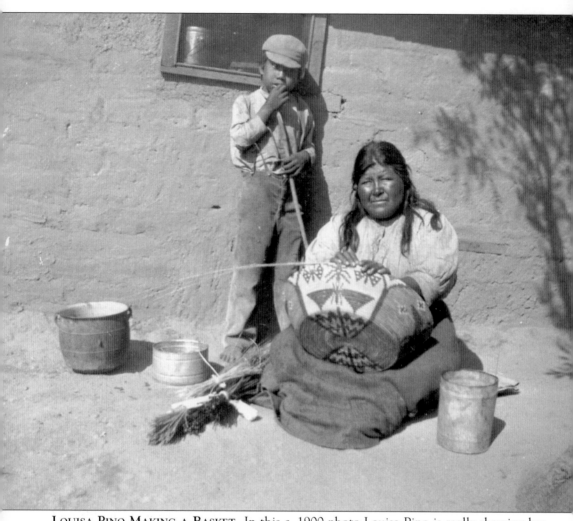

LOUISA PINO MAKING A BASKET. In this *c.* 1900 photo Louisa Pino is really showing her expertise at basket making—a trademark skill that the Serranos exhibited for centuries. (Courtesy of Pauline Murillo.)

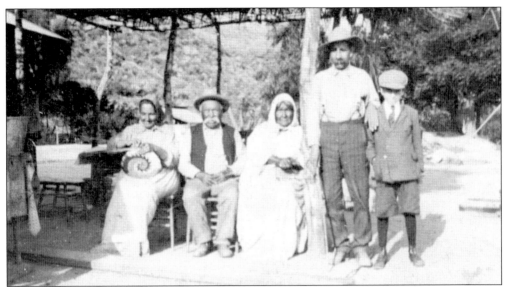

SANTOS AND DOLORES MANUEL. This is a rare photograph of Santos and Dolores Manuel (second and third from the left). Their daughter, Jesusa Manuel, is weaving a "singular" basket. After a series of conflicts between some desert American Indian tribes and settlers, there was a month long campaign in 1867 to wipe out all natives from the valley, including the peaceful and innocent Serranos. Thanks to the leadership of Santos Manuel, the few surviving Serranos took to the foothills northeast of San Bernardino. Since a presidential order in 1891, that settlement has become known as San Manuel Reservation. When Santos Manuel died in 1919, he was 105 years old. (Courtesy of Pauline Murillo.)

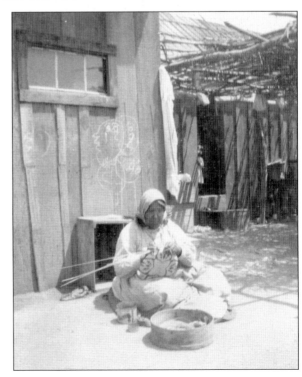

DOLORES CRISPIN MANUEL.
Dolores Crispin Manuel is seen here weaving a basket at her home on the San Manuel Reservation. She taught this craft to many women. (Courtesy of Pauline Murillo.)

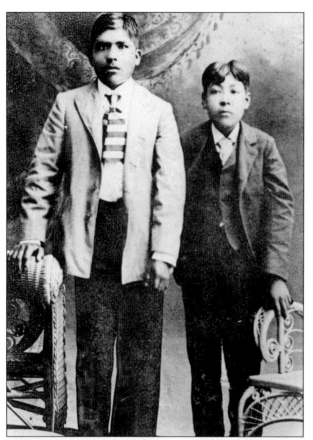

YGNACIO AND JOE MANUEL.
Ygnacio and Joe Manuel are dressed in their best suits in this 1901 photo. They are the sons of Santos and Dolores Manuel. Their father was Serrano and the mother was Cahuilla, so the boys share both lineages. (Courtesy of Pauline Murillo.)

BUILDING A SERRANO HOME.
The land encompassing the old Serrano Indian settlement of Amuscopiabit in Cajon Pass is now owned by the San Bernardino County Museum Association. In this 1999 photo, museum association caretaker and local historian Mike Hartless is giving the author (left) a few pointers on how the natives built their brush-covered homes. These small structures, called *kiich* (singular) or *kii-kiich* (plural), looked like upside down baskets, averaging 10 feet in diameter. (Courtesy of author.)

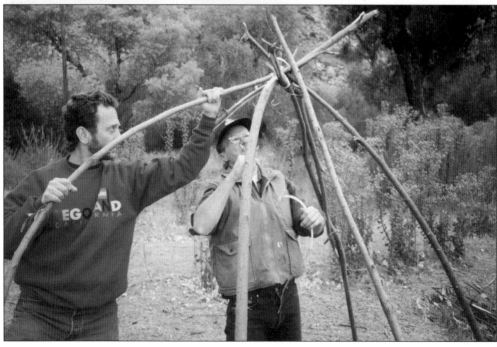

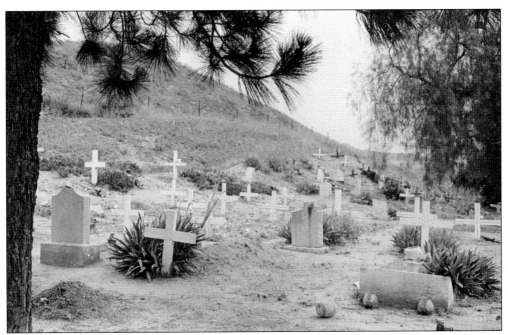

SAN MANUEL RESERVATION CEMETERY. The San Manuel Reservation Cemetery is an important and sacred place to the Serranos as well as other local tribes, especially the Cahuilla. (Courtesy of Pauline Murillo.)

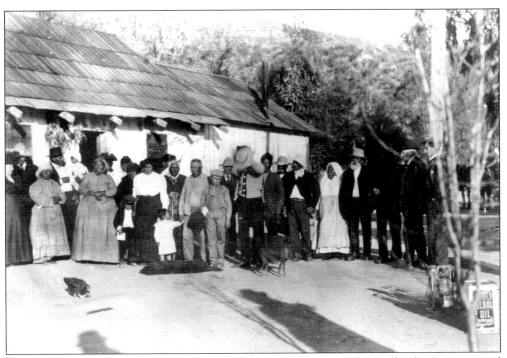

SAN MANUEL BIG HOUSE. This is San Manuel's "Big House." Traditionally, the Serranos used places like this for gatherings such as weddings, funerals, and other special ceremonies. (Courtesy of Pauline Murillo.)

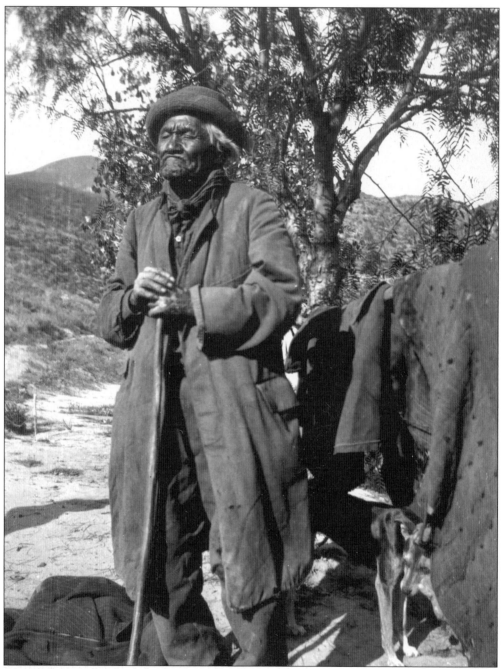

A GABRIELINO INDIAN. Members of various local Native American tribes visited the San Manuel reservation. This stoic photo is of a Gabrielino called Waruhoos. His Hispanic name was Jose Zalvidea. (Courtesy of Pauline Murillo.)

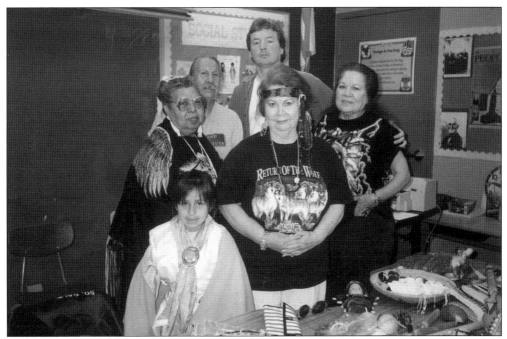

SERRANOS TODAY. The people in this photo are keeping their ancestors' culture alive. They spoke and performed native dancing for students at Anderson School in San Bernardino in 1998. The three women pictured here are, left to right: Virginia Robles (half Cahuilla), Virginia Johnson, and Goldie Walker (both half Serrano). Also featured are young Amanda Robles, Don Robles, and Mark (the tall one) Cochran. (Courtesy of author.)

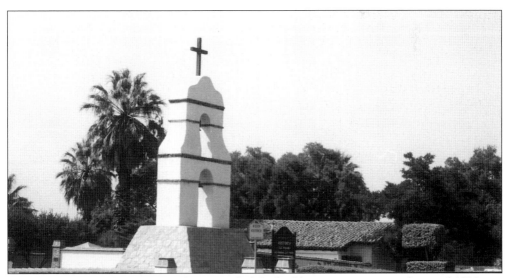

SAN BERNARDINO ASISTENCIA. A group of adobe buildings was constructed around 1830 as a branch of the San Gabriel Mission. Work was started, but the complex was not fully completed when secularization forced the padres to abandon the mission establishments in 1834. During the 1930s, the current buildings were built. Although various liberties were taken during the reconstruction, the San Bernardino Asistencia is one of San Bernardino County's visible links with the fascinating Mission Period of California's history. (Courtesy of author.)

17

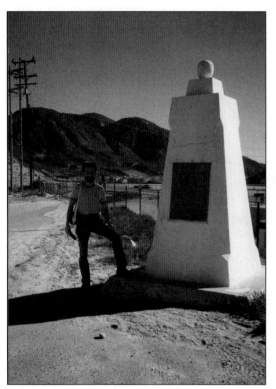

SANTA FE AND SALT LAKE MONUMENT.
This 1917 monument is located in the Cajon Pass at Highway 138, exit from northbound I-15, east to Wagon train Road, and south to the end of the road. It commemorates the bravery of the first explorers, traders, and settlers who traveled this early trail through the Cajon Pass during the 1830s and '40s. (Courtesy of author.)

DON ANTONIO MARIA LUGO

DON ANTONIO MARIA LUGO. Don Antonio Maria Lugo was one of the largest landowners in California's Mexican rancho days. In 1842 he helped his sons and a nephew to secure the Rancho San Bernardino. The Lugos operated the 35,000-acre cattle ranch until selling out to Mormon settlers in 1851.

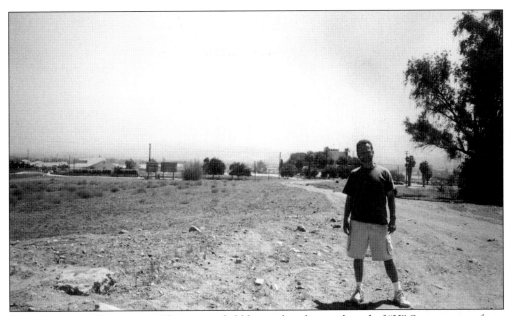

SETTLEMENT OF POLITANA. This empty field located at the south end of "K" Street, across from San Bernardino Valley College, witnessed numerous historical events over the years. During the 1840s this was a rendezvous site for selling horses by the Californios to the New Mexican traders that were heading back to the Santa Fe area along the Old Spanish Trail. Later "Politana" (named after an early settler) became a temporary home for group of settlers arriving from Abiquiu, New Mexico. And, after this group moved on to Agua Mansa, this became Cahuilla Indian chief Juan Antonio's village. (Courtesy of author.)

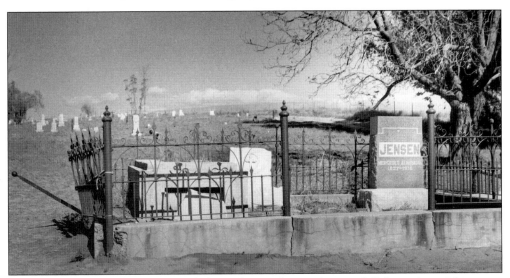

AGUA MANSA CEMETERY. Located about three miles southwest of Colton, Agua Mansa was the first substantial community in the San Bernardino Valley. In 1862, the Santa Ana River flooded and washed away all of the homes in the community, except for the church, Cornelius Jensen's store, and the cemetery, which is shown here. Only the cemetery remains today. Established in 1852, it is the oldest cemetery in San Bernardino County. (Courtesy of San Bernardino Historical and Pioneer Society.)

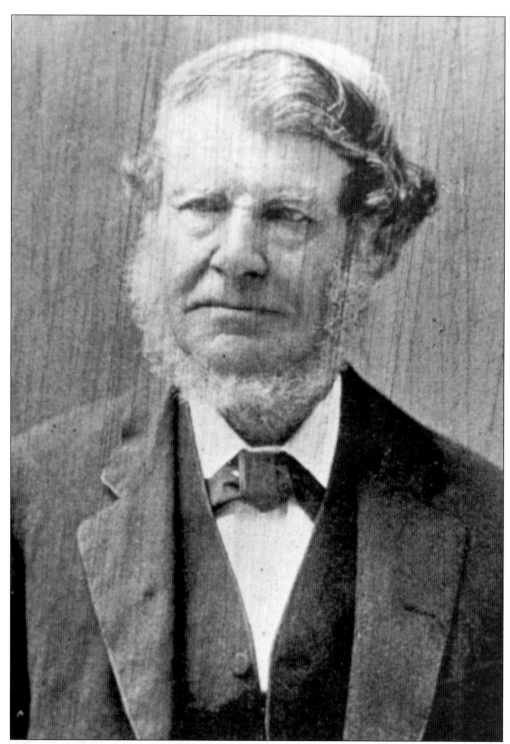

CORNELIUS JENSEN. Former sea captain Cornelius Jensen moved to Agua Mansa in 1853. He built an adobe home/mercantile store next to the church. His residence was the only one to survive the devastating flood of 1862. (Courtesy of San Bernardino Historical Society.)

Two
A Boom Town in the South Land
1851–1900

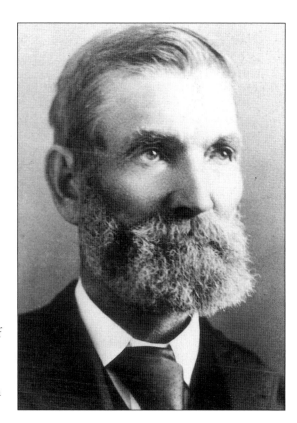

DAVID SEELY. In 1851, David Seely was appointed captain of fifty wagons of Salt Lake pioneers destined to establish the city of San Bernardino. He was the first Stake President of the Mormon Church in the colony. (Courtesy of San Bernardino Historical Society.)

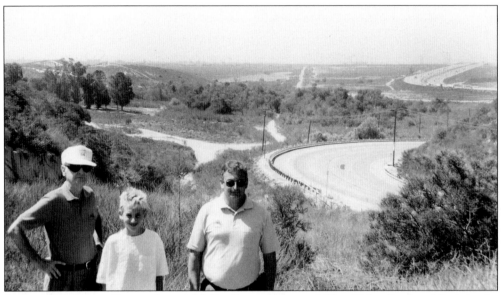

SITE OF SYCAMORE GROVE. Located 1.5 miles southwest of Glen Helen Regional Park in the outskirts of San Bernardino, Sycamore Grove was the site of the first camp of the Mormon pioneers from Salt Lake when they arrived in the San Bernardino Valley in 1851. The emigrants stayed here until the purchase of the Rancho San Bernardino from the Lugo family was finalized in September. The grove of Sycamore trees between Lytle Creek and Cajon creek east and south of I-15's "Devore Cut-off" was replaced years ago with a vineyard. A thick forest of trees—as you can see in the photo behind John Cataldo, Jay Cataldo, and Glen Helen Park assistant superintendent John Gericke—can be seen there today. (Courtesy of author.)

LEWIS JACOBS. Lewis Jacobs, a Jewish miner and peddler, was the first independent merchant outside of the Mormon colony. He was co-owner of a mountain sawmill, started the Bank Of San Bernardino, founded the Paradise Lodge B'nai B'rith, and helped established the Home of Eternity Cemetery. (Courtesy of San Bernardino Historical Society.)

THE MORMON STOCKADE. A major colony of Mormon settlers was established during the latter part of 1851 on land purchased from Jose del Carmen Lugo. As rumors surfaced regarding a massive Indian attack, a fort or stockade was established approximately where the present county courthouse is today. Fortunately, the "uprising" never materialized. Within a year plans were under way for establishing the city of San Bernardino. (Courtesy of San Bernardino Public Library.)

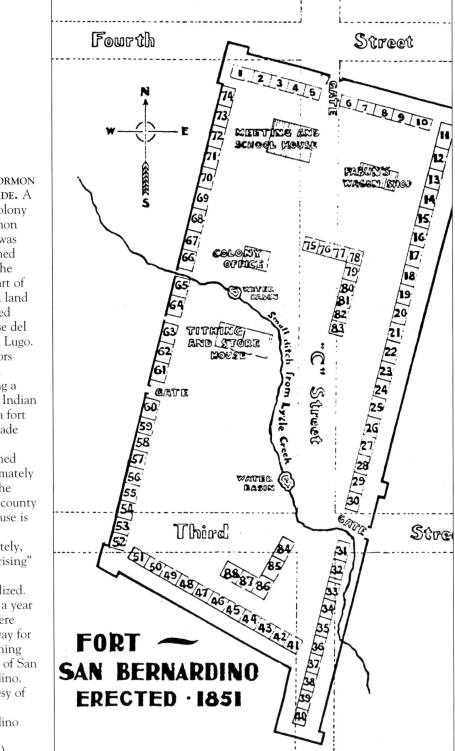

Plat #	Name			
		4	Mathews, Joseph	
28	Aldridge	5	Mathews, William	
24	Andrews, Simeon		Mills, William	
27	Blackburn, Abner			
	Blackburn, Thomas			
63	Brown, Joh, Sr.		Miner (kept store)	Blackwell, Hiram
	Bybee, Alfred	74	Miner (store)	Casteel, Joshua
	Burk, Charles		McIlvane, Jerry	Clark, Francis
59	Button, Montgomery E.		McGee, Henry	Hanks, George
70	Casteel, Jacob		Ray	Hughes, John
	Crismon, Charles	D,E,F	Rich, Charles C. (Apostle)	Jones, Alonzo
37-40	Crosby, William (Bishop)	31	Rolfe, Samuel	Phelps, John
	Crandel, Charles	35	Rolfe, Gilbert E.	Smithson, Bartlett, & family
40	Cox, A.J. (kept restaurant)	68	Rollins, Henry (residence)	Holladay, David
	Cox, William J.	69	Rollins, Henry (store)	Taylor, Norman
	Collins, Albert W. ("Peter")		Rowan, Mrs. (Lizzie	Taylor, Elmer
	Cook, John		Flake) (African-American)	Taylor, "Old Man"
67	Cummings, Albert	22	Seeley, David	Welsh, Mathew
	Carter, Orlando	1	Shepard, Lafayette	
	Davidson, J.J.		Shepard, Samuel (father of	
66	Daley, Edward		Lafayette)	
33	de Lin, Andrew P.		Shepard, Carlos	
	Dixon, David	65	Sherwood, Henry G.	
	Egbert, Robert		Sparks, O.S.	
"R"	Fabun, Clark S. (wagon shop)	64	Stoddard, Sheldon	
	Fabun, Clark S. (residence)	32	Stuart, John	
36	Flake, Mrs. (widow William)		Sullivan, Archie	
	Garner, George		Swarthout, Truman	
53	Glazer, Louis (residence)		Stout, William (1st	
54	Glazer, Louis (store)		schoolmaster)	
	Grundy, Isaac		Smith, "Bill"	
51	Gruard, Benjamin F.		Summee, Gilbert (blacksmith)	
2	Hakes, W.V.		Stewart, James	
30	Harris, John, Sr.		Taft, Daniel M.	
	Harris, Moses (had 2 sons,	72,73	Tanner, Albert	
	Silas and John, with		Tanner, Joseph	
	families)		Tanner, Freeman (brothers-in-	
58	Hoagland, Lucas (later		law of Amasa Lyman)	
	Addison Pratt)	60	Tanner, Sidney	
48	Hofflin, Samuel	71	Tanner, Mrs. ("Mother")	
36	Hopkins, Richard R. (kept		Taylor	
	store)		Tenney, Nathan C. (Bishop)	
	Holladay, John		Thomas, Daniel M.	
61	Hunt, Cap't. Jefferson (2 sons,		Thorp, Theodore	
	Gilbert and Marshall)		Tyler, U.U.	
62	Hunter, Cap't. Jesse		Turley, Theodore	
	Hyde, William	42	Whitney	
	Hyde, Joseph	2	Meeting House and School	
	Jones, David	P	Office of Lyman and Rich	
	Kartchner, William D.	oo	Tithing House and Store	
25,26	Lee, Rupert J.	A,B,C	Lyman, Amasa	
	Lytle, Cap't. Andrew			

PIONEERS LIVING INSIDE THE MORMON STOCKADE. Here is the list of those early Mormon settlers that lived inside the stockade. (Courtesy of San Bernardino Public Library.)

AMASA MASON LYMAN. Amasa Lyman was part of Mormon president Brigham Young's entourage that traveled to Utah in 1847. In 1851, he, along with fellow apostle Charles Rich, was appointed to oversee the establishment of a colony and way-station in San Bernardino. He served as mayor of the new city in 1854. (Courtesy of San Bernardino Historical Society.)

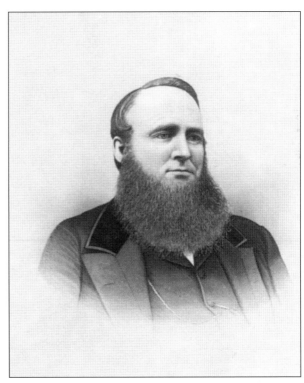

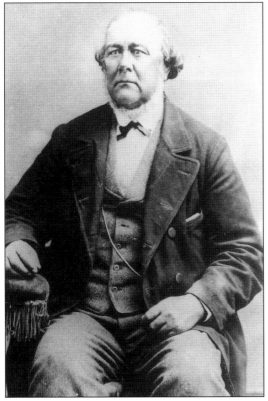

CHARLES COULSON RICH. An appointed apostle and trusted friend of Brigham Young, Charles Rich was sent along with Amasa Lyman to supervise the new San Bernardino colony. He eventually became the second mayor of San Bernardino. When the saints were recalled to Salt Lake in 1857–58, Rich was one of the first to return. (Courtesy of author.)

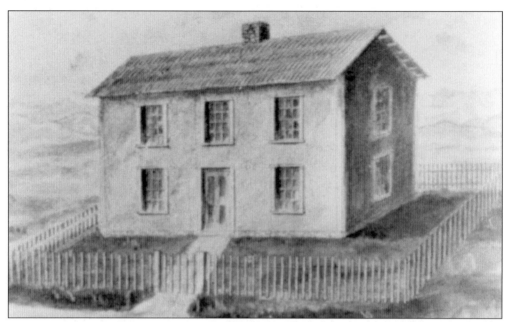

MORMON COUNCIL HOUSE. This is an early sketch of the Mormon's Council House. As San Bernardino's first public building, this served multiple purposes. Built in 1852, this was used as the post office, school, and church. The Council House also served as the county's courthouse from 1854 to 1858. (Courtesy of San Bernardino Public Library.)

LUGO ADOBE, MORMON COUNCIL HOUSE, AND AMASA LYMAN HOME (RUINS). This photograph was taken after the 1865 fire at Amasa Lyman's house. It shows the adobe built by the Lugos around 1839 (left), the ruins of Lyman's house with its tall chimneys (left center), the Mormon Council House immediately next door to it on the south, and a portion of Pine's Hotel beyond it across 3rd Street. These were located near today's Arrowhead Avenue and 3rd Street. (Courtesy of San Bernardino Historical Society.)

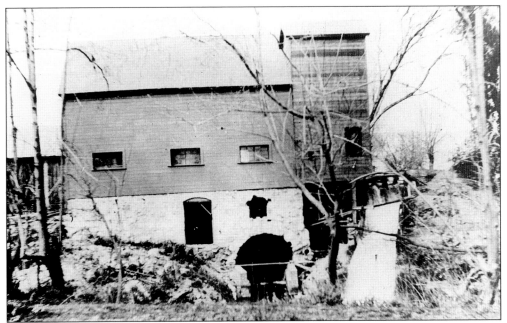

MORMON FLOUR MILL. The two Mormon apostles who were in charge of the San Bernardino settlement, Amasa Lyman and Charles Rich, chose a site near what is now the corner of Allen and Mill Streets for a flourmill in May of 1852. The 25-by-40-foot structure had two sets of burrstones driven by water brought from Warm creek in a mile long millrace. Adjacent to it was a 30-by-70-foot adobe storehouse and a water-powered thresher. (Courtesy of San Bernardino Historical Society.)

ROUTE OF BASE LINE SURVEY. Base Line Street runs through San Bernardino County from Highland across the valley through a number of communities, continuing as far west as Azusa in Los Angeles County. It was constructed on the southern California base line and surveyed by Col. Henry Washington in 1852. (Courtesy of author.)

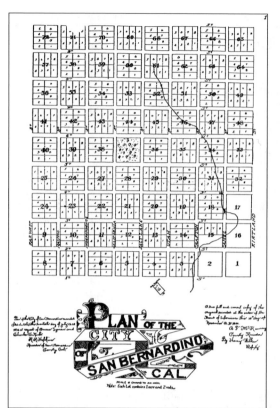

PLAN OF ORIGINAL ONE-MILE SQUARE CITY. The plan of the original mile-square city as laid out by Henry G. Sherwood in 1853 reflects Mormon names. Later, the north-south streets were changed to "letter" names. (Courtesy of San Bernardino Public Library.)

MAP OF 1853 MORMON ROAD TO LOS ANGELES. This map, probably drawn around 1890, still shows the 1853 Mormon road from San Bernardino to Los Angeles. The "Cajon" road extends southward from the Cajon Pass and the "Sonora" Road was an early travel route from Sonora, Mexico, to Los Angeles. (Courtesy of San Bernardino Public library.)

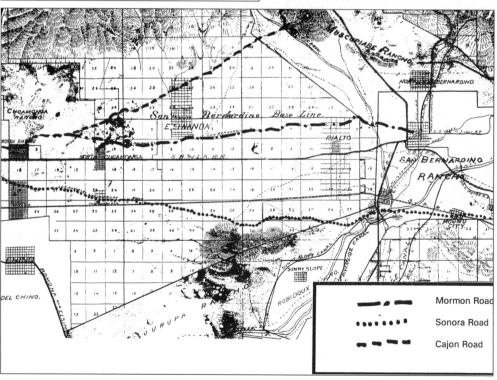

OLD MORMON FLUME. In 1855 water from Waterman Canyon was diverted into Town Creek near today's "H" Street at the east end of Little Mountain. The water then followed Town Creek into San Bernardino. During the early 1880s, the ditch was somewhat realigned to irrigate farms and orchards north of town. (Courtesy of Jay Cataldo.)

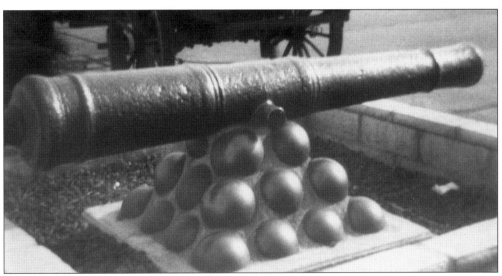

SPANISH CANNON. Located in front of the Native Sons of the Golden West headquarters in the Del Rosa section of San Bernardino, this old cannon has had a storied past. It was brought from Mexico to San Diego in 1818 and helped ward off pirates who had been raiding sections of the coast. Later it was used by the Californios against the Americans in the Battle of Cahuenga during the Mexican-American War, during the 4th of July celebration between the Mormons and non-Mormons in 1856, and by Jerome Benson during a dispute with Mormon leaders in 1857. The cannon's final colorful episode was during a much heated feud in 1859 between the two San Bernardino physicians known as the "Gentry–Ainsworth" affair. (Courtesy of author.)

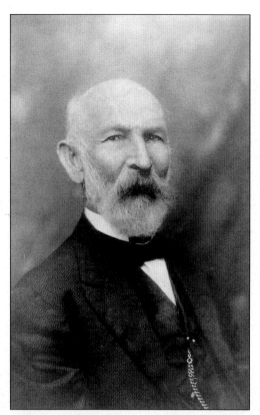

FRED PERRIS. In his long career in San Bernardino, Fred Perris seemingly had a hand in just about every major project. He arrived in town in 1853 at the age of 16 and during that year assisted H.G. Sherwood survey the mile-square city and lay out the original grid streets. In 1857 he drew the official map of the San Bernardino Rancho. His later map of San Bernardino and Riverside Counties became the most widely used by prospectors and desert travelers before the advent of the Auto Club of Southern California. His greatest work, however, was in luring the Santa Fe Railroad (now Burlington Northern Santa Fe) to extend its line into San Bernardino and through the Cajon Pass. (Courtesy of Christina Perris.)

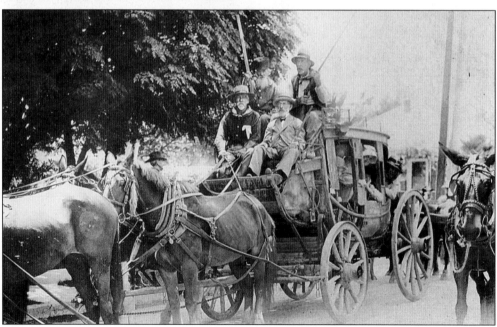

PERRIS AND COX IN PARADE. Fred Perris (right of stagecoach driver) and fellow pioneer, Silas Cox, (seated behind Perris) participate in the parade commemorating the city of San Bernardino's Centennial in 1910. (Courtesy of Christina Perris.)

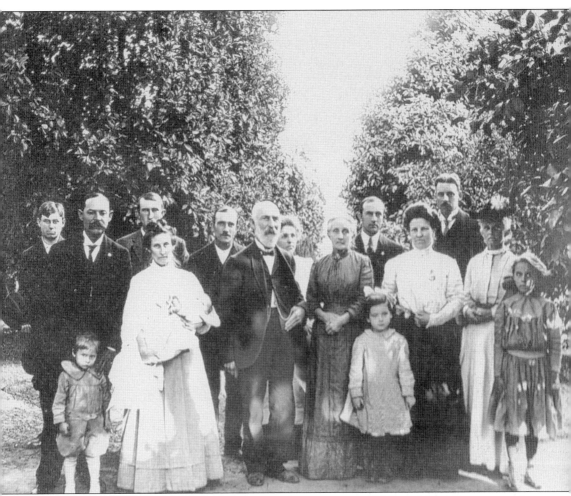

PERRIS FAMILY. The Perris family gathers to commemorate the 50th wedding anniversary of Fred and Mary Perris in 1909. (Courtesy of Christina Perris.)

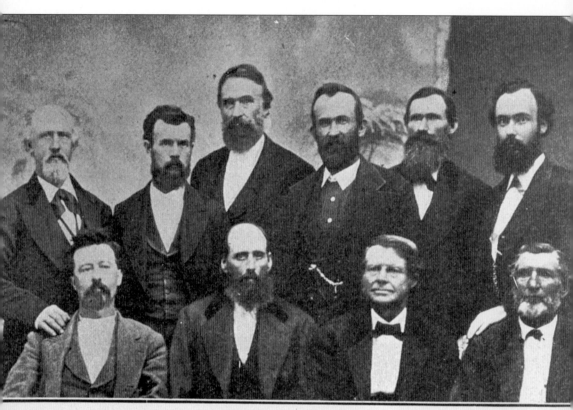

M. Willis, W. J. Curtis, J. J. Rousseau, John Mayfield, Harden Yager, Henry Goodc
 Judge Dist. Att'y Surveyor Sheriff Treasurer Supt. Schoo
 Sydney P. Waite, John Garner, Cornelius Jensen, James W. Wate
 County Clerk Supervisor Supervisor Supervisor

1870s Civic Leaders. This group of men represented some of the county's civic leaders during the mid 1870s. Many of these pioneers arrived in San Bernardino during the '50s and '60s. (Courtesy of San Bernardino Historical Society.)

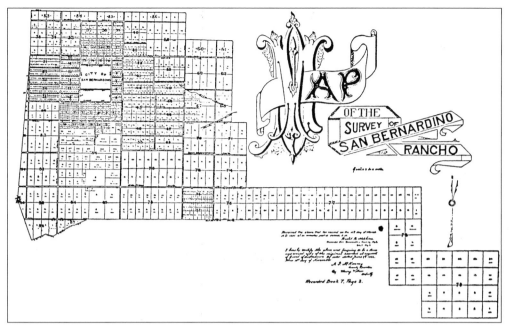

MAP OF SAN BERNARDINO RANCHO. The San Bernardino Rancho was surveyed for the Mormons by Fred T. Perris in 1857. (Courtesy of San Bernardino Public Library.)

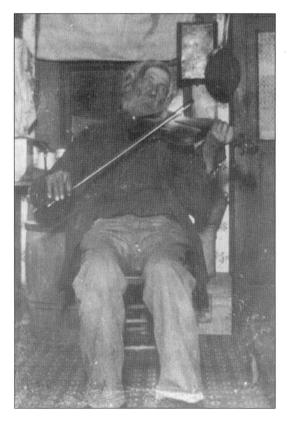

WILLIAM F. HOLCOMB. William Francis "Bill" Holcomb, shown here playing the fiddle as an old man, came to California from Indiana during the Gold Rush. He tried his luck in a number of locations with little success. In 1860, he finally hit the jackpot up in the San Bernardino mountain valley now bearing his name. The avid grizzly hunter lived out the remainder of his adventurous life in San Bernardino. Holcomb died in 1912 at the age of 81 and is buried in Pioneer Cemetery. (Courtesy of W.R. "Bob" Holcomb.)

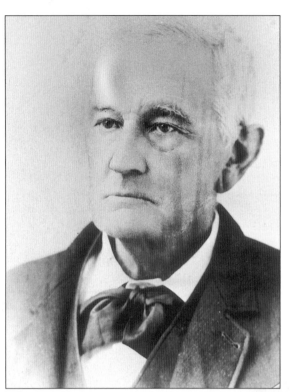

BEN BARTON. Dr. Benjamin Barton was a man of many talents. He lived in San Bernardino from 1857 until his death at the age of 75 in 1898 and during that time he served the city and county as a physician, postmaster, assemblyman, and also had a grape vineyard for winemaking. (Courtesy of San Bernardino Historical Society.)

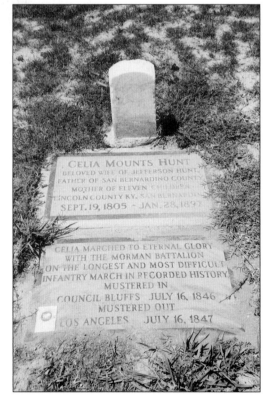

GRAVE OF CELIA MOUNTS HUNT. Among the many graves of Mormon settlers buried in Pioneer Cemetery is one for Celia Mounts Hunt. She was married to Capt. Jefferson Hunt, one of the most prominent leaders of the young San Bernardino community. She was allowed by Brigham Young to stay in town so that she could remain with her daughters. (Courtesy of author.)

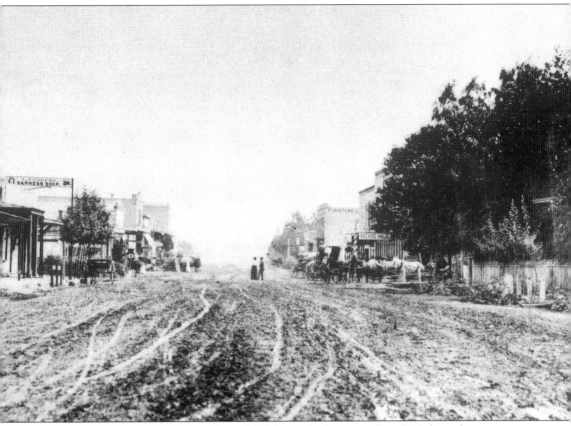

THIRD STREET IN 1865. This great shot of 3rd Street looking east from "D" shows how a part of the "Old West" San Bernardino was back then. Saloons stood at each corner of that intersection, prompting the interesting moniker, "Whiskey Point." (Courtesy of author.)

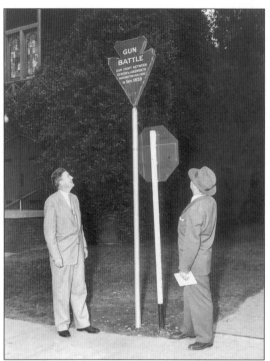

SITE OF GUN BATTLE. It was high anxiety time for San Bernardino's residents as the impending Civil War that would tear apart the country drew frighteningly near. On the eve of the conflict, heated arguments between the townsfolk were frequent and occasionally resulted in violence, setting the scene, in 1859, for a shooting fiasco between the two local physicians in town. Fortunately, both Dr. Alonzo Ainsworth (a Union supporter) and Dr. Thomas Gentry (a Confederate sympathizer) were lousy shots. In 1859, there were only two doctors in town. (Courtesy of San Bernardino Historical Society.)

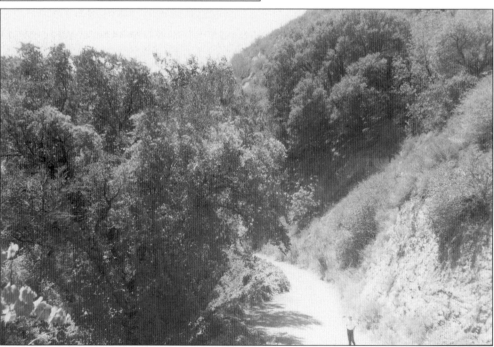

SWARTHOUT LOGGING ROAD. In 1867 Nathan Swarthout expressed an interest in cutting cedar trees growing in the vicinity of Saw Pit Canyon. Cedar made excellent fence posts, which were needed on the farms and ranches in the valley. The "Bailey Canyon Road" as it was sometimes called, was used until 1872, when the Twin and City Creek Turnpike was constructed north of Del Rosa. That's the author's son, Jay, standing on the road. (Courtesy of Author.)

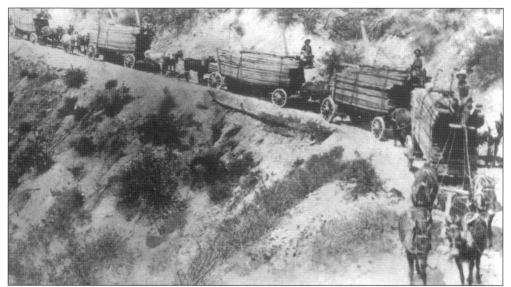

TWIN AND CITY CREEK TOLL ROAD. Lumbering in the San Bernardino Mountains was a flourishing business during the second half of the 19th century. One of the busiest logging roads was the Twin and City Creek Turnpike (also known as the Daley Canyon Toll Road). Constructed in 1870, this roadway started in Del Rosa, with a tollhouse located just north of the present Del Rosa Ranger Station. The wagon route followed Daley canyon over the mountain crest and down into the present day town of Blue Jay. (Courtesy of author.)

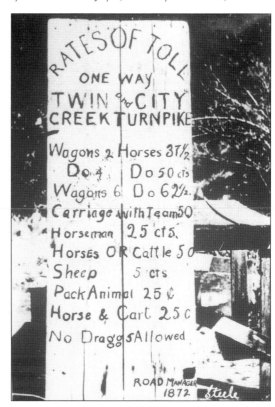

TOLL ROAD COSTS. These are the prices for traveling along the Twin and City Creek Turnpike back in the 1870s. These may seem like cheap prices today, but they were pretty hefty more than a century ago. (Courtesy of Author.)

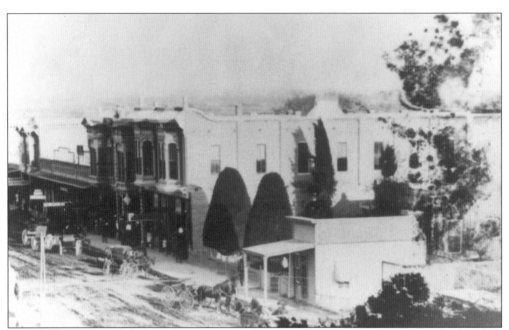

MATTHEW BYRNE STORE. Featured in this 1870 photo of 3rd Street between "D" and "E" is Matthew Byrne's general store. No doubt, the proprietor had a booming business. (Courtesy of San Bernardino Historical Society.)

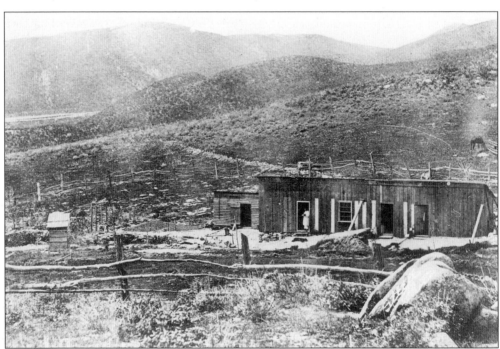

DAVID NOBLE SMITH'S SANITARIUM. This 1876 photo is of David Noble Smith's Sanitarium up at Arrowhead Springs. He used the natural hot mineral water to treat people with various illnesses. This simple wooden building would eventually be followed by more elaborate hotels. (Courtesy of San Bernardino Historical Society.)

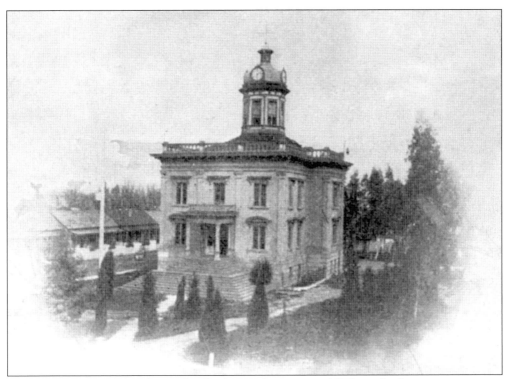

1874 COURT HOUSE. On the south side of Court Street, east of "E," was the first permanent court house in San Bernardino County in 1874. (Courtesy of San Bernardino Historical Society.)

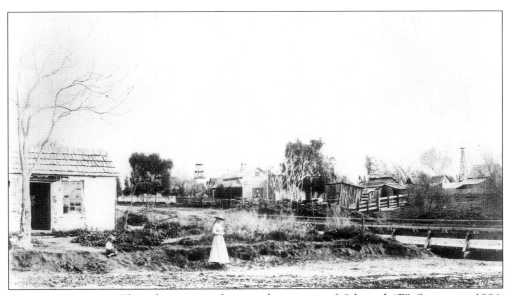

PIONEER MOTHER. This photo was taken at the corner of 9th and "E" Streets in 1884. According to available information, the picture is of "Daisey Slater's mother." (Courtesy of San Bernardino Historical Society.)

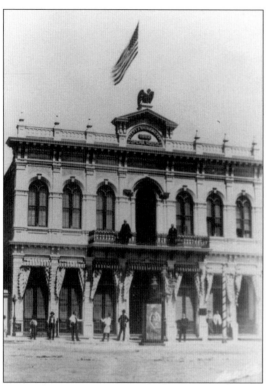

SAN BERNARDINO OPERA HOUSE. Located east of "D" at Court Street, this theater was built by mountain-man-turned-businessman James W. Waters in 1882—before Los Angeles got its first such establishment. Fine entertainment featuring world-renowned performers such as Maude Adams, Lillian Russell, Sarah Bernhardt, Al Jolson, and George M. Cohan flourished until 1927 when Court Street was opened from "D" Street through to the "new" San Bernardino County courthouse on Arrowhead Avenue. (Courtesy of author.)

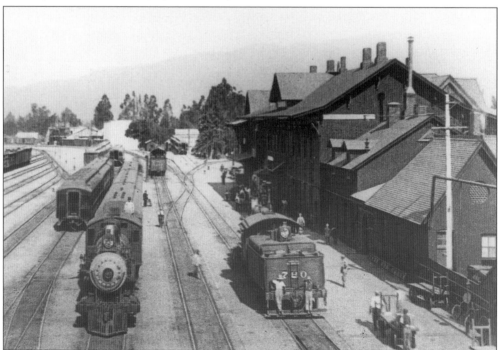

FIRST SANTA FE DEPOT. The first train arrived here in 1883 after controversy at Colton's Southern Pacific crossing. A large wooden station was built at this site in 1886, connected by a horse car line with the center of town. (Courtesy of San Bernardino Historical Society.)

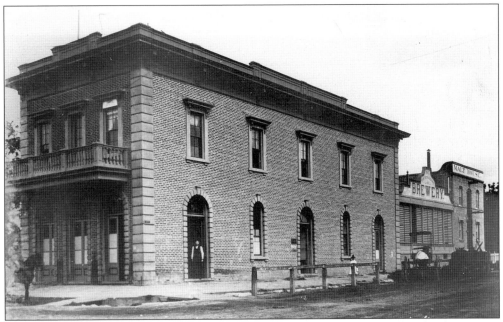

ANDRESON BREWERY. John Andreson built his small brewery (center structure in photo) on the northwest corner of 3rd and "E" Streets in 1884. (Courtesy of San Bernardino Historical Society.)

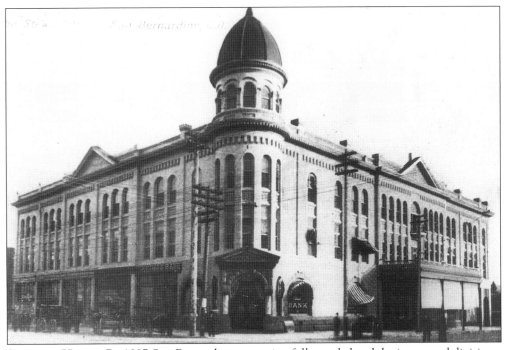

STEWART HOTEL. By 1887 San Bernardino was going full speed ahead, laying out subdivisions, building homes, hotels, and business blocks. The Stewart Hotel, featured in this photo, was built during this time at the corner of 3rd and "E" Streets. It had an elevator, gas and electric lights, and a "ladies only" entrance. (Courtesy of San Bernardino Historical Society.)

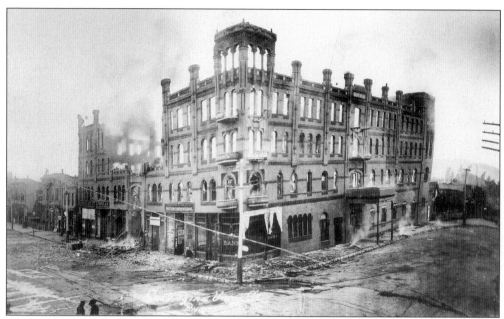

STEWART HOTEL ON FIRE. An elaborate building with 400 rooms, the Stewart was destroyed by fire but was rebuilt in 1892. (Courtesy of San Bernardino Historical Society.)

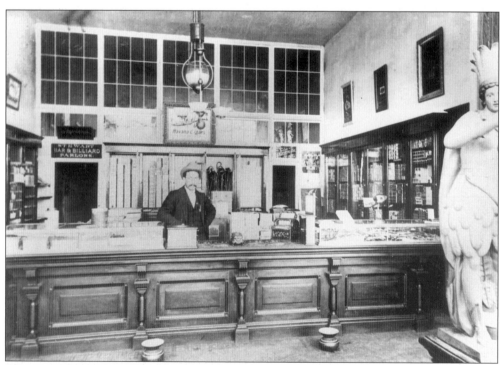

STEWART HOTEL CIGAR STORE. The Stewart Hotel Cigar Store became a social center and place where residents could buy a Louisiana Lottery ticket, a popular item at the time. (Courtesy of San Bernardino Historical Society.)

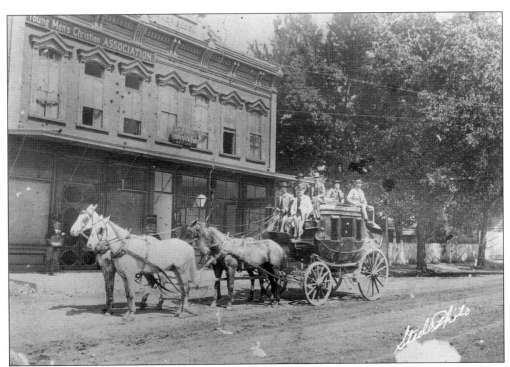

LATE 1880's STAGE AND GARNER BUILDING. In this photo, Starke's Stage is posing in front of the Garner Building during the late 1880s. The brick structure still stands today on "D" Street between 4th and Court. The Garner Building is the oldest commercial building in San Bernardino. (Courtesy of San Bernardino Historical Society.)

GREGORIO AND MANUELA QUINTANA. This 1887 photo shows Gregorio Quintana, who was born in Agua Mansa, seated on the right. His wife, Manuela Gardunio Quintana, is standing on the right. (Courtesy of San Bernardino Public Library.)

43

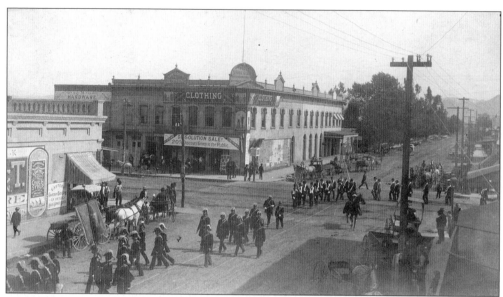

1887 Street Parade. This is another 19th century festive event, San Bernardino style. The marchers are turning left off 3rd Street on to "D"—a corner known for years as "Whiskey Point." (Courtesy of San Bernardino Historical Society.)

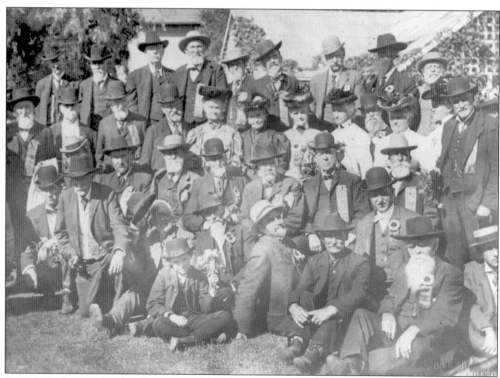

San Bernardino Pioneer Society. In January, 1888, a group of former frontiersmen gathered to form a society that would preserve the history of San Bernardino County. Members of this "San Bernardino Society of California Pioneers" are posing in front a log cabin that they built for meetings. (Courtesy of San Bernardino Historical Society.)

44

PIONEERS POSING FOR A PICTURE. Posing for this publicity shot in 1888 for the San Bernardino Society of California Pioneers (Pioneer Society) is one tough group of hardy frontiersmen. Pictured from left to right are: William F. Holcomb, John Brown Jr., John Brown Sr., George Miller, and B.B. Harris. (Courtesy of author.)

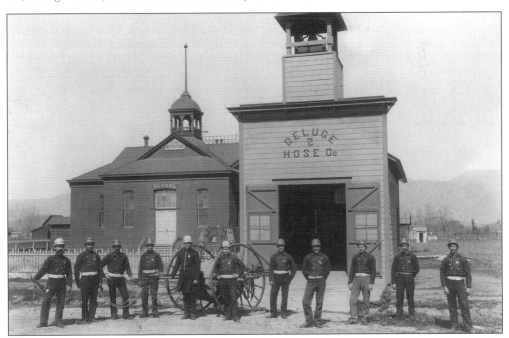

DELUGE HOSE CO. #2. San Bernardino's second fire station, Deluge Hose Co. #2, stood in the northern (at the time) part of town at 9th and "F" Streets. Its fire fighting apparatus consisted of a single hand drawn hose cart. This photo was taken in the 1880s. (Courtesy of author.)

45

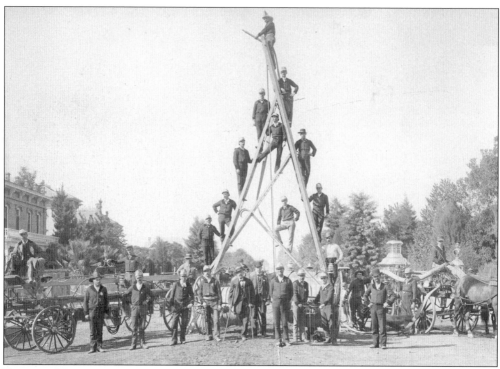

Pioneer Hose #1 and #2 Alert Hook and Ladder #1. This classic shot is of the Pioneer Hose #1 and #2 Alert Hook and Ladder Company are showing off their ladders in 1889. (Courtesy of Steven Shaw.)

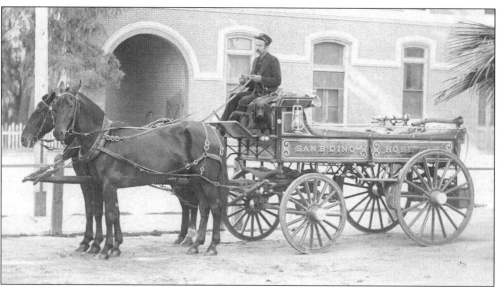

Hose Wagon. The first hose wagon in San Bernardino was built in 1890 because the fire department redesigned its water system: fire hydrants replaced the steam pumper. This photo was taken in 1896 and the wagon still used for historical events and parades (even the Rose parade) thanks to the efforts of local firemen and local history preservationists, Steven Shaw and Allen Bone. (Courtesy of Steven Shaw.)

STAGE COACH C. 1890. This is a Los Angeles-bound stage in front of Starke's Hotel at the southeast corner of 3rd and Arrowhead *c.* 1890. (Courtesy of San Bernardino Historical Society.)

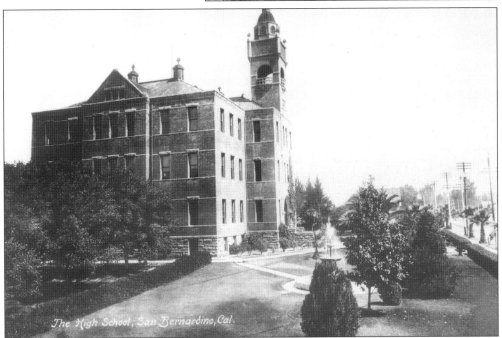

The High School, San Bernardino, Cal.

SAN BERNARDINO HIGH SCHOOL. For several years there were only private secondary schools in the city. Then in 1883, two individually run institutions were housed in temporary quarters under the name San Bernardino High School. Finally, the first permanent San Bernardino High School, shown here, was built on east side of 8th Street near "E" in 1891. It was replaced in 1915 with a new facility further north on "E" Street. (Courtesy of author.)

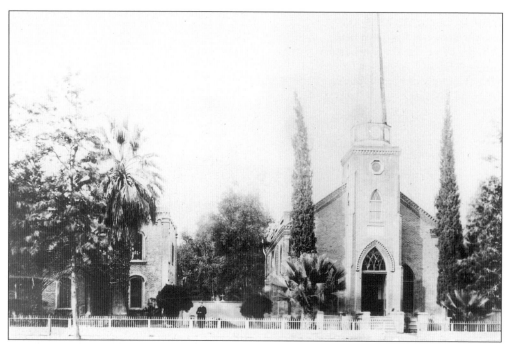

ST. BERNARDINE'S CHURCH. This photo of St. Bernardine's Catholic Church was taken around 1900. It was built in 1870 at the corner of "F" and 5th Streets and was replaced with a newer structure in 1910. (Courtesy of San Bernardino Historical Society.)

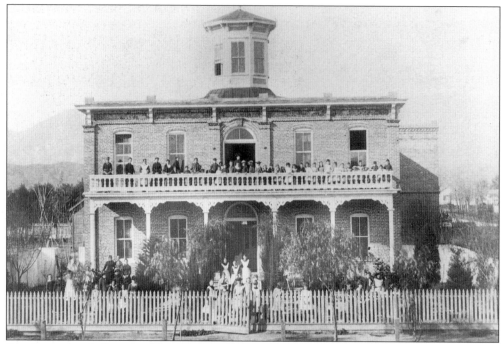

ST. CATHERINE'S SCHOOL. This is St. Catherine's Convent School taken around 1890. It was built 10 years earlier thanks to the funding by Catherine Quinn. It was located just east of St. Bernardine's Church. (Courtesy of San Bernardino Historical Society.)

EARP'S 1890 GOLDEN WEDDING ANNIVERSARY. The family of legendary lawman Wyatt Earp came out west and settled in San Bernardino twice—once in 1864 and again during the late 1870s. In this photo, the Earp parents, Nicholas Porter and Virginia Ann Earp, are posing for their 50th anniversary on July 30, 1890 in a San Bernardino studio. They lived out the remainder of their lives in nearby Colton, where Nick ran a saloon for a while and later served as justice of the peace and city recorder. (Courtesy of author.)

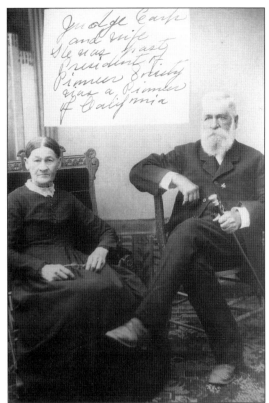

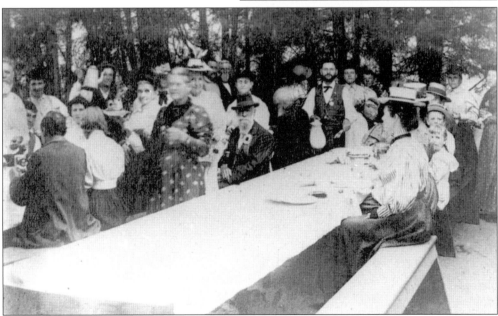

1893 NICK EARP AND ANNIE ALEXANDER AT PIONEER GATHERING. Nicholas Earp's wife died in 1893 and he remarried later that year. In this photo, Earp and his new wife, the former Annie (Cadd) Alexander, are at a Pioneer Society gathering shortly after their wedding. Nick is seated near the center of the table, with Annie standing to his right. (Courtesy of author.)

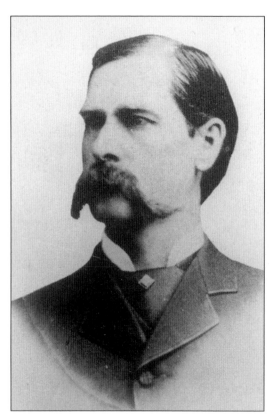

WYATT EARP. Famed Old West personality Wyatt Berry Stapp Earp lived in the San Bernardino area for a few years during the late 1860s, during the family's first move out west. After his folks came out a decade later, Wyatt was into other things—like Dodge City and Tombstone. However he visited his family frequently over the years. This photo of Wyatt was taken in 1887. (Courtesy of author.)

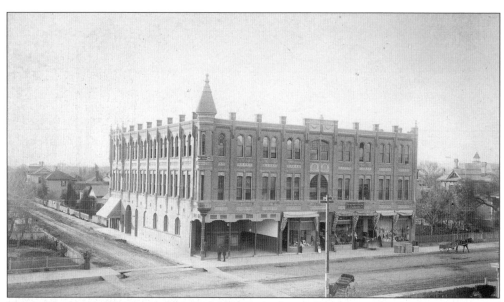

DREW-ANDRESON BUILDING. This is the Drew-Andreson Building at the northwest corner of Court and "E" Streets in 1888. The post office was housed here from that year until 1903. (Courtesy of San Bernardino Historical Society.)

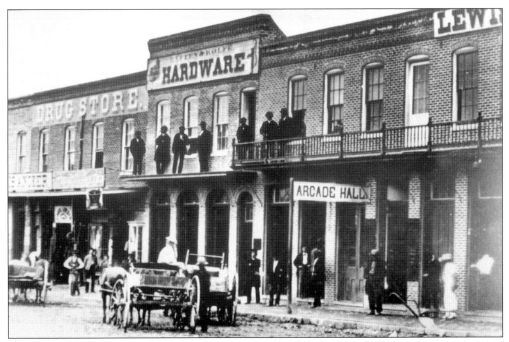

HARDWARE STORE AND ARCADE HALL, C. 1890. Another good "Old West" shot of San Bernardino, c. 1890, is seen here. With the use of electricity in its infancy stages, one would wonder what type of arcade games they had back then. (Courtesy of author.)

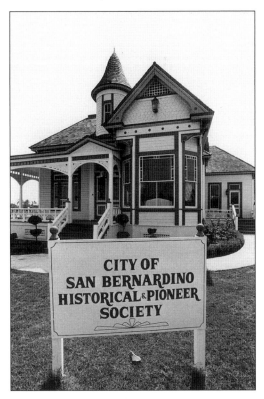

HERITAGE HOUSE. The city of San Bernardino Historical and Pioneer Society moved the 1891 home of Judge George E. Otis to the "carriage corner" of 8th and "D" Streets, one of the last rounded street corners in San Bernardino. The Society renovated and brought back the original Victorian charm in 1983. They added a "carriage house" for monthly meetings and a library. (Courtesy of San Bernardino Historical Society.)

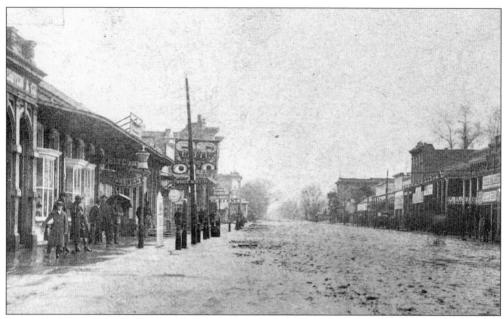

RAIN POURING DOWN. In this photograph, rain is pouring down on 3rd Street in February, 1884, just before a tremendous flood that year. (Courtesy of San Bernardino Historical Society.)

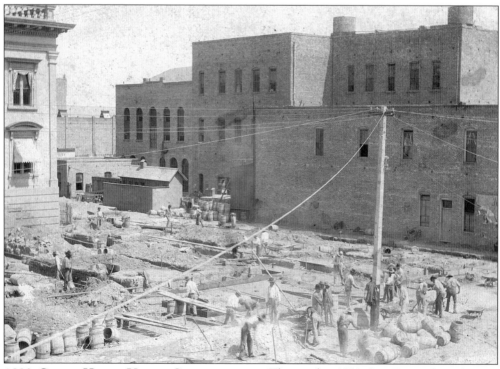

1893 COURT HOUSE UNDER CONSTRUCTION. This is the 1893 San Bernardino County Court House when it was being built near the corner of Court and "E" Streets. (Courtesy of San Bernardino Historical Society.)

1893 County Courthouse. The 1893 County Court House stood near the corner of Court and "E" Streets, a short distance from its 1874 predecessor. This new facility was heavily involved with a controversy leading to separation of Riverside County. It was torn down when the new and current courthouse was built on Arrowhead Avenue and Court in 1926. (Courtesy of San Bernardino Historical Society.)

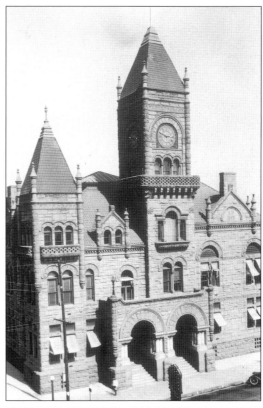

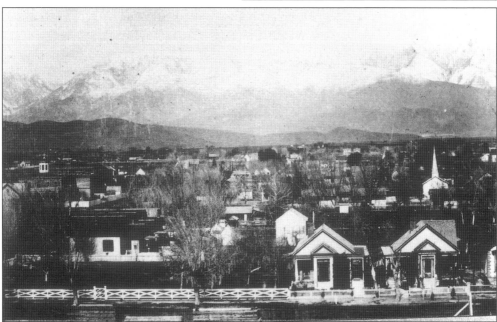

1890s View of San Bernardino. This 1890s view of San Bernardino was taken from the upper level of the court house. With all of that snow on the mountains, this photo was probably taken between January and March. (Courtesy of author.)

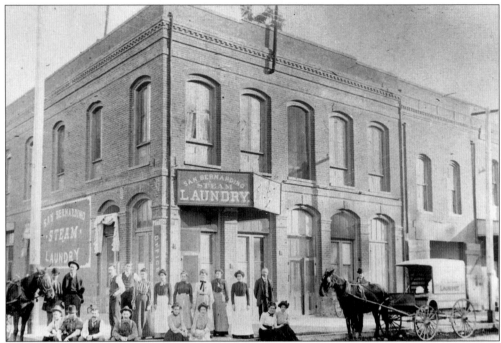

SAN BERNARDINO STEAM LAUNDRY. This *c.* late 1890s picture on 599 Court Street features the San Bernardino Steam Laundry. It appears that those nice folks were pretty excited about being photographed. (San Bernardino Historical Society.)

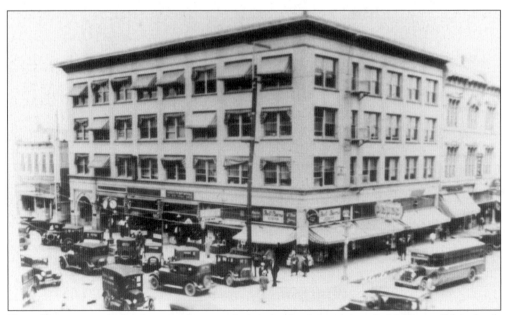

KATZ BUILDING. A pioneer merchant and civic leader from the early 1850s until his death in 1899, Marcus Katz was one of the first Jewish settlers in San Bernardino. The Katz Building evolved from a small modest structure on 3rd and "E" Streets during the 1880s into a very impressive four-story building a decade later. This photo was taken *c.* 1900. (Courtesy of San Bernardino Historical Society.)

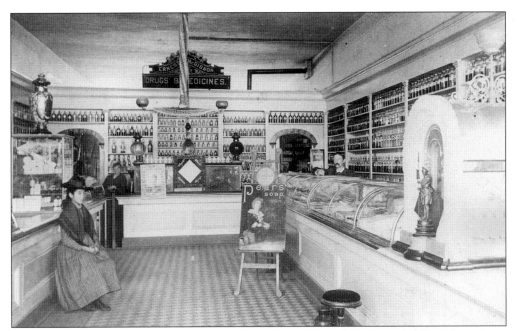

ERNEST MCGIBBON'S DRUG STORE. This is the interior view of Ernest McGibbon's Drug Store on the corner of 3rd and "D" Streets, which was built during the late 1890s. Some years later it became one of Towne and Allison's Drug Stores. (Courtesy of author.)

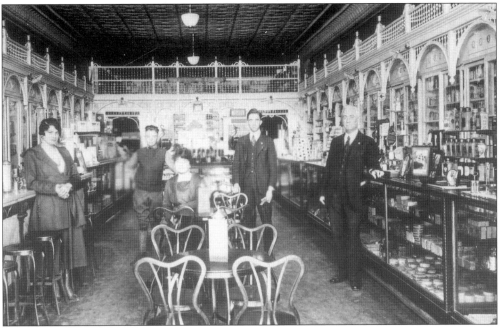

TOWNE, SECCOMBE, AND ALLISON'S DRUG STORES. Towne, Seccombe, and Allison Drug Pharmacies held a good business in town until the 1940s. In addition to offering its patrons all the remedies and cures of a city drug store, one of the three stores (located near "D" and "E" Streets in downtown) served delicious homemade ice cream. The proprietors were Frank Towne, William Seccombe, and Monte Allison. (Courtesy of author.)

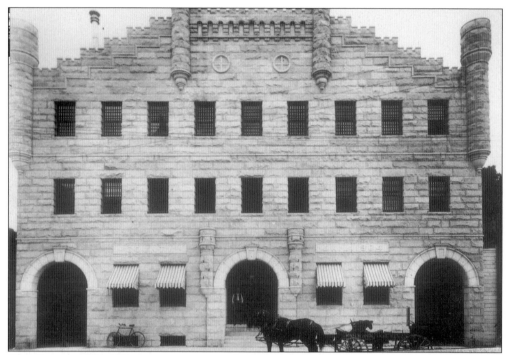

City Jail c. 1890s. This eerie, uninviting-looking structure on Court Street served the city as the jail for a number of years. (Courtesy of author.)

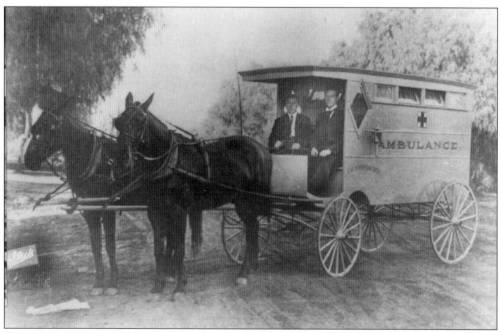

Early 20th Century Ambulance. Two years after moving to the city of Colton in 1905, I.M. Knopsnyder bought a stable and livery business. Soon afterward he added an ambulance (shown here) to his repertoire which served the San Bernardino County Hospital. He later bought an undertaker business as well. (Courtesy of San Bernardino Historical Society.)

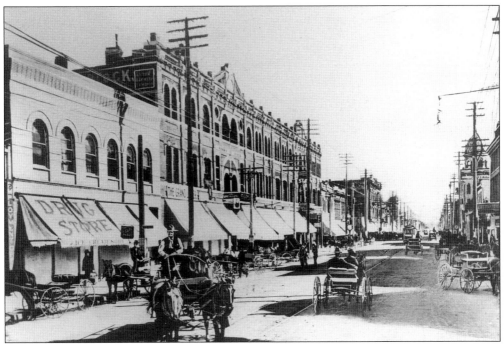

1898 VIEW OF THIRD STREET. A typical day on 3rd Street looking east from "E" in 1898. Within the next decade you can just imagine what a few Model T's would look like in this same photo. (Courtesy of San Bernardino Historical Society.)

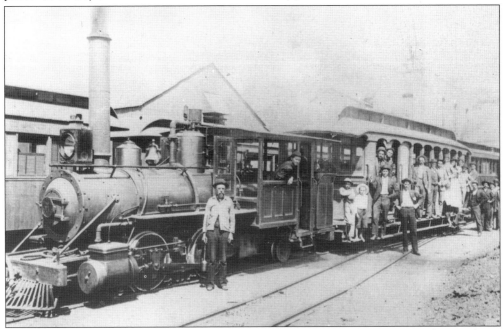

1899 HARLEM MOTOR ROAD. Engine No. 1 of the Harlem Motor Road is seen about to leave San Bernardino in 1899. This narrow-gauge steam line from San Bernardino to Harlem Springs was completed a decade earlier by the San Bernardino, Arrowhead, and Waterman Railroad Company. (Courtesy of San Bernardino Historical Society.)

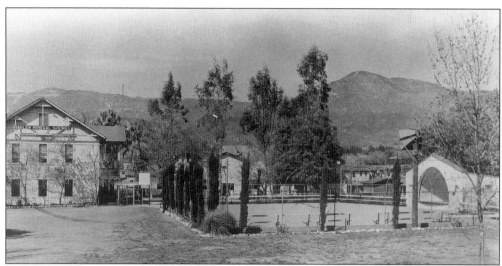

HARLEM SPRINGS. The Spanish called the San Bernardino Valley Agua Caliente, "hot water," because of the multitude of geothermal natural hot springs filtering underground. Because of this natural resource, hot mineral springs resorts were quite popular from the 1890s through the 1940s. One of the most popular was Harlem Springs located at Victoria and Base Line, just east of town. (Courtesy of San Bernardino Historical Society.)

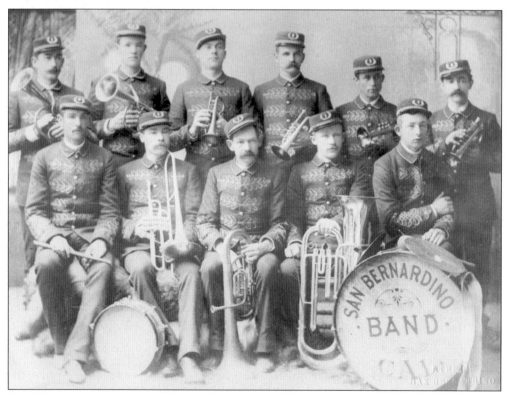

SAN BERNARDINO BAND. This proud group of men entertained the city's residents with musical delights around the turn of the century. They were known as the San Bernardino Band. (Courtesy of San Bernardino Public Library.)

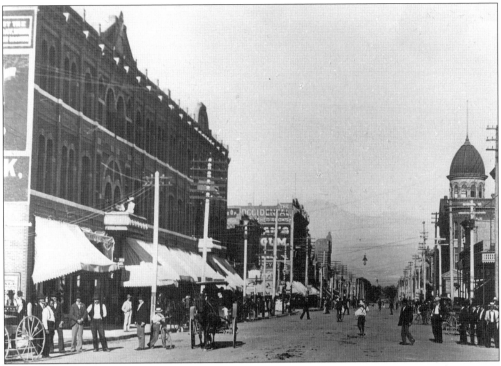

1900 3RD AND D. This is a nice view of busy downtown San Bernardino in 1900. The scene is along 3rd Street looking east from "D" Street. (Courtesy of San Bernardino Historical Society.)

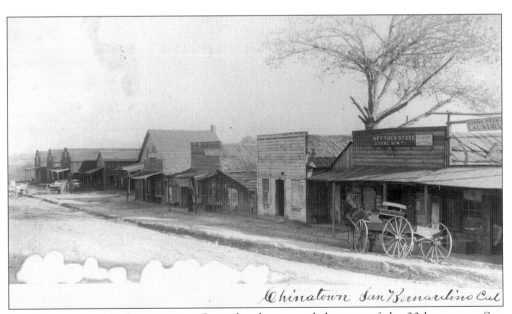

SAN BERNARDINO'S CHINATOWN. In its heyday around the turn of the 20th century, San Bernardino's Chinatown had as many as 400–600 residents. Their homes and businesses were largely concentrated along 3rd Street between Arrowhead Avenue and Sierra Way. (Courtesy of San Bernardino Historical Society.)

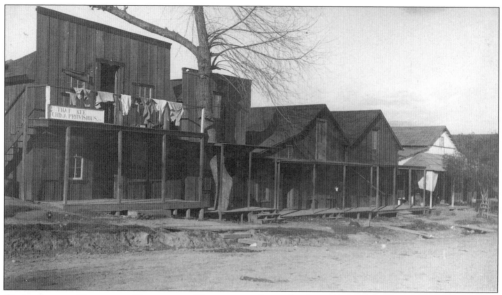

CHINATOWN BUSINESS DISTRICT. Chinatown flourished until the late 1920s. By that time, fires and other agents had wiped out most of the wooden shacks shown in this c. 1900 shot. The county redeveloped the area for its offices, which is how it remains today. (Courtesy of San Bernardino Historical Society.)

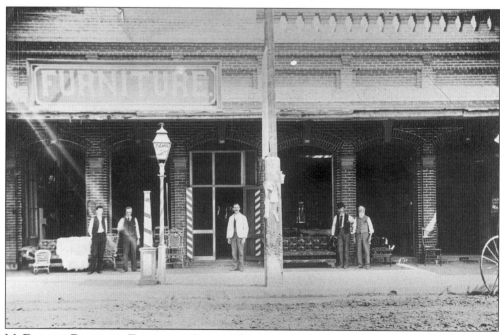

MCDONALD BROTHERS FURNITURE STORE. This late 19th-century photo features the McDonald Brothers Furniture Store on "D" Street near 3rd. (Courtesy of San Bernardino Historical Society.)

Three

THE PLACE TO BE
1901–1950

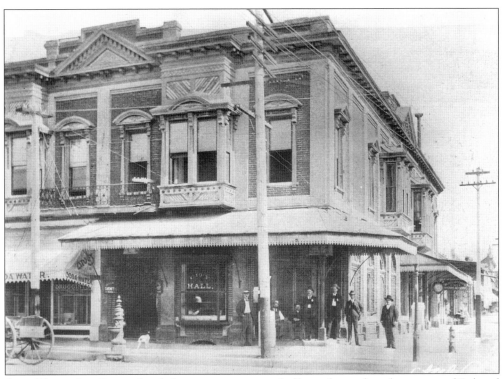

CITY HALL. San Bernardino's first permanent city hall was located at the corner of 3rd and "D" Streets in 1901. This photo was taken around that time. (Courtesy of San Bernardino Historical Society.)

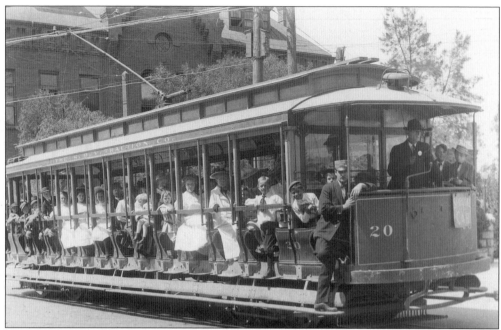

TRACTION COMPANY 1902. In 1902 several groups of businessmen purchased a franchise to operate electric trolleys in and between Colton, San Bernardino, Redlands, and Highland. Three principal firms emerged, only to consolidate under the San Bernardino Valley Traction Company. (San Bernardino Historical Society.)

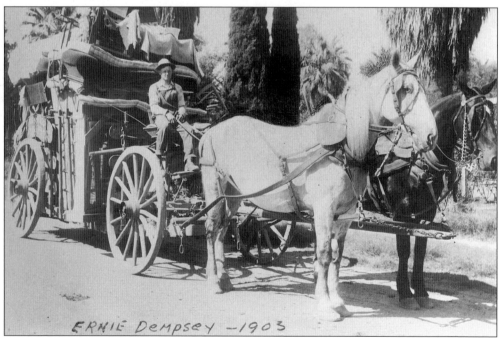

HEAP AND HEAP TRANSFER. George Heap and his family operated a transfer business in the San Bernardino area during the turn of the past century. This photo was taken in 1903. (Courtesy of San Bernardino Historical Society.)

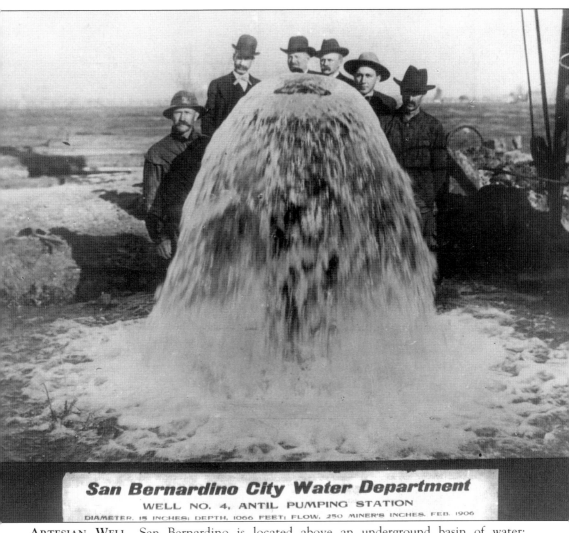

San Bernardino City Water Department
WELL NO. 4, ANTIL PUMPING STATION
DIAMETER, 15 INCHES; DEPTH, 1066 FEET; FLOW, 250 MINER'S INCHES. FEB. 1906

ARTESIAN WELL. San Bernardino is located above an underground basin of water; therefore, its residents never have a shortage of drinking water even during the most severe droughts. This fascinating shot taken in 1906 shows one of many artesian wells throughout the city during its early days. The well was located along 6th Street between Waterman and Tippecanoe Avenues. (Courtesy of author.)

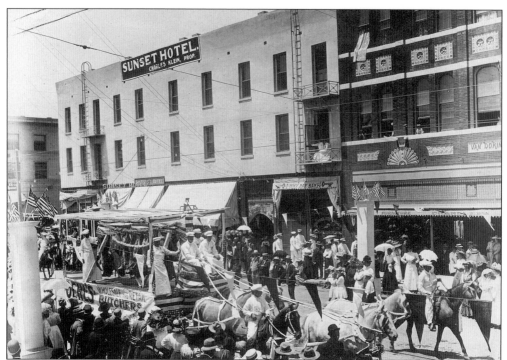

Street Fair on "E." It looks like a big celebration of sorts at 3rd and "E" Streets in 1906. Notice the horse drawn float in front of the Sunset Hotel. (Courtesy of San Bernardino Historical Society.)

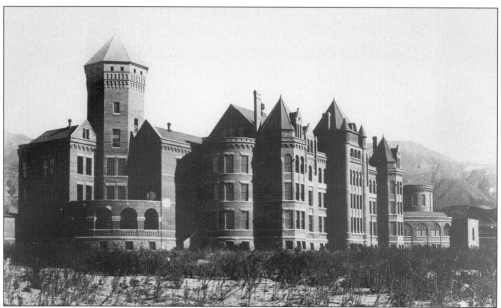

Patton State Hospital. Known originally as the Insane Asylum and today called Patton State Hospital, this spooky looking structure was the third state institution built in Southern California. Built in 1890, this photo was taken around the turn of the century. It is located east of the city limits on Highland Avenue. (Courtesy of author.)

ROBERT W. WATERMAN. Local resident, Robert W. Waterman was governor of California from 1887 until 1891. He was instrumental in establishing Patton State Hospital, for developing the Waterman Rifles, and for his Waterman Silver Mine near today's city of Barstow. (Courtesy of San Bernardino Public Library.)

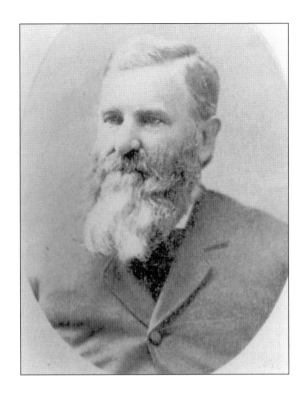

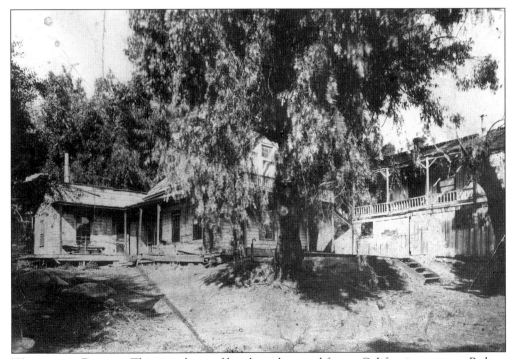

WATERMAN RANCH. This is a photo of local resident and future California governor Robert W. Waterman's ranch in the San Bernardino foothill community of Waterman Canyon, taken in 1908. (Courtesy of author.)

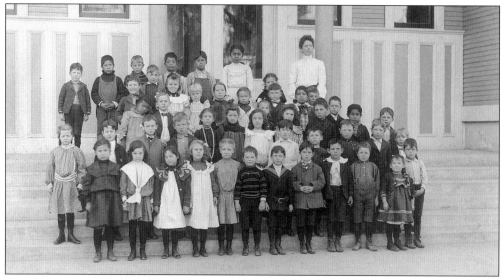

4TH STREET SCHOOL IN 1904. School children today sure don't dress like they did back in 1904. In this photo taken on January 28th of that year, the proud youngsters were the second graders at Fourth Street School. (Courtesy of San Bernardino Historical Society.)

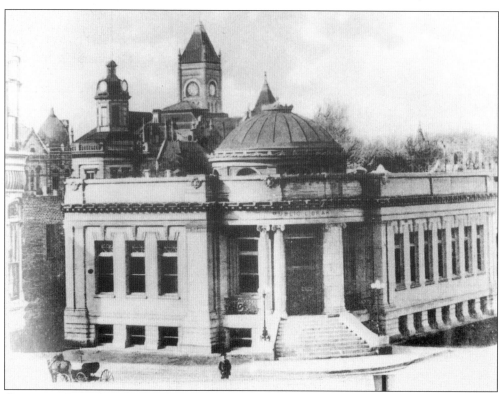

CARNEGIE LIBRARY 1904. Philanthropist Andrew Carnegie donated millions of dollars throughout the country in order to build libraries. One of his gems was located at the corner of 4th and "D" Streets in 1904, the year this photo was taken. It served the city of San Bernardino until 1958. (Courtesy of San Bernardino Historical Society.)

1910 STREET SCENE. San Bernardino really knew how to show its patriotic colors in this 1910 photo. This 4th of July Celebration was held on "E" Street in downtown. (San Bernardino Historical Society.)

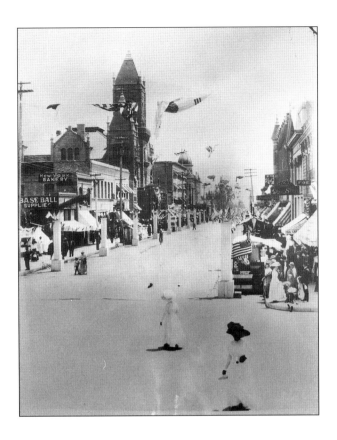

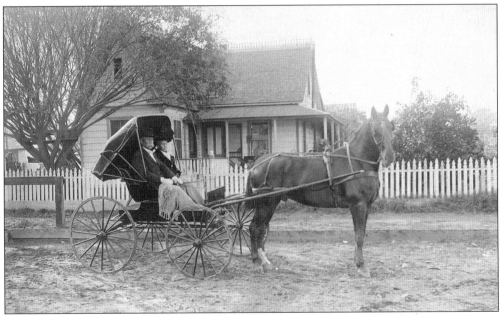

LORD HOMESTEAD. This peaceful shot is of a family buggy and ranch is the Pioneer George Lord's homestead on 1073 Mt. Vernon in 1910. The house was built in 1888. (Courtesy of San Bernardino Historical Society.)

HORSE HITCHING RING. A reminder of simpler times, here on 4th Street east of Mt. View Avenue, is a horse hitching ring. The date it was placed at this spot is not known. (Courtesy of author.)

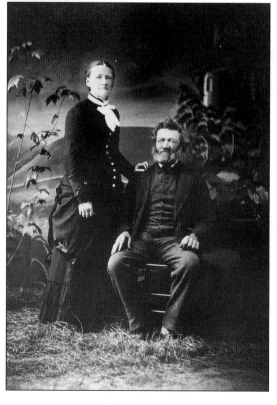

JULIUS AND MARY MEYER. German-born Julius Meyer and his wife, Mary, are posing here in an undated photo some time before his death in 1912 at the age of 83. The Meyers arrived in the northwestern part of San Bernardino, locally known as Verdemont, in 1882. His family eventually owned over 2,000 acres in that area, using most of the land for growing grapes for wine making. (Courtesy of author.)

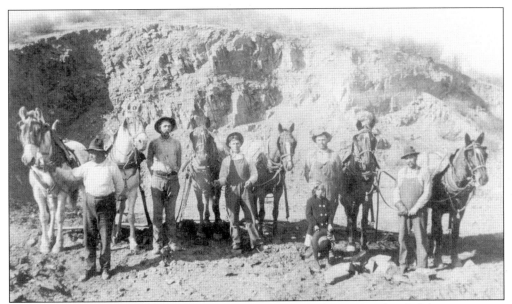

PERRIS HILL RESERVOIR. This is the top of Perris Hill when it was leveled for a reservoir. The man at the far right is Walter Tompkins. The others are unknown. (Courtesy of San Bernardino Public Library.)

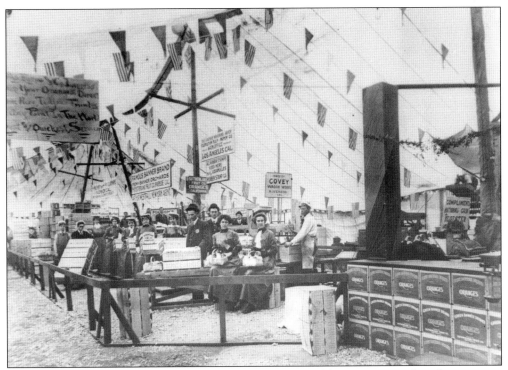

FIRST NATIONAL ORANGE SHOW. Citrus fairs had been held in San Bernardino from time to time, but the first "National Orange Show" was held inside a tent in 1911 on the northwest corner of Fourth and "E" Streets. This event, now held at the corner of Mill and "E", has become a popular annual event to this day. (Courtesy of San Bernardino Historical Society.)

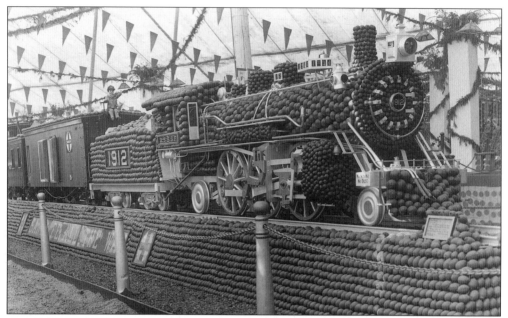

1912 NATIONAL ORANGE SHOW. This is one of the many citrus displays at this 1912 event. At one time there were nearly 50,000 acres of oranges throughout the San Bernardino Valley. Today there are less than 5,000. (Courtesy of San Bernardino Historical Society.)

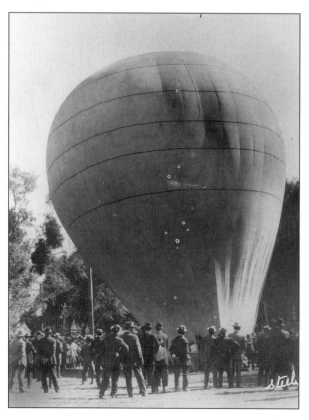

BALLOON AT URBITA SPRINGS. Everyone appears to be in awe in this 1911 picture. They are admiring the balloon ascension at Urbita Springs Park. (Courtesy of San Bernardino Public Library.)

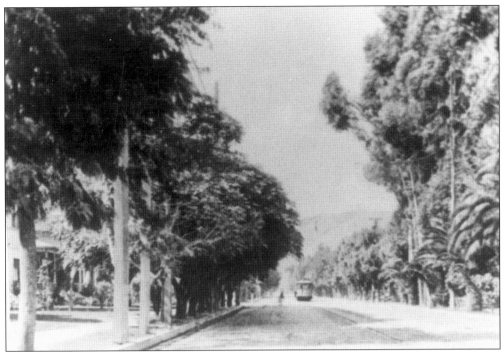

1915 N. "D" STREET. This a view of "D" Street looking north. Notice the cable "Big Red" car coming southbound. (Courtesy of San Bernardino Historical Society.)

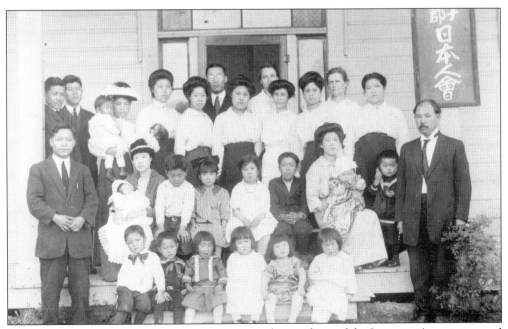

JAPANESE ASSOCIATION. This 1916 picture was taken in front of the Japanese Association and church which was located on "D" Street between 2nd and 3rd Streets. That's retired San Bernardino teacher and lifelong city resident Masako Hirata and her mother in the second row, third from the right. (Courtesy of Masako Hirata.)

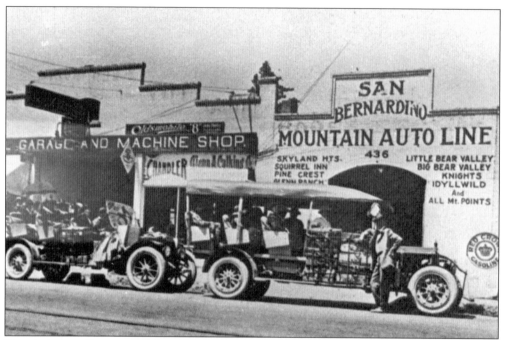

FIRST AUTO GARAGES. This 1916 photo shows how this new invention, called the automobile, can change a town. This is a good glimpse of one of San Bernardino's first auto garages. (Courtesy of author.)

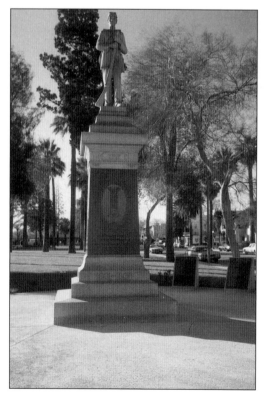

SOLDIERS AND SAILOR'S MONUMENT. The Soldier's and Sailor's Monument in Pioneer Park at 6th and "E" Streets was erected by a group of men who made up some of the last survivors from the Civil War. It was dedicated in April 1916, on the anniversary of the Lee's surrender at Appomattox. (Courtesy of author.)

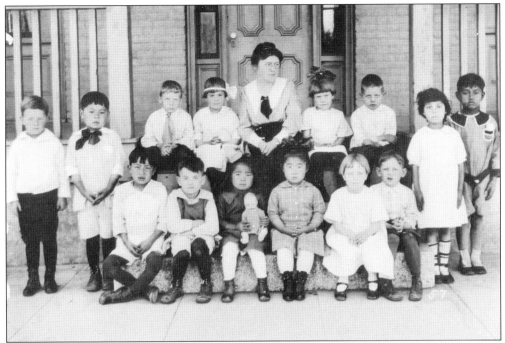

FOURTH STREET KINDERGARTEN CLASS. Posing in this picture is the kindergarten class at 4th Street School in 1919. The teacher, Ethel McClaren, taught school in San Bernardino for 43 years. Masako Hirata, a future teacher herself and the donor of this photo, is seated in the front row fourth from the left. (Courtesy of Masako Hirata.)

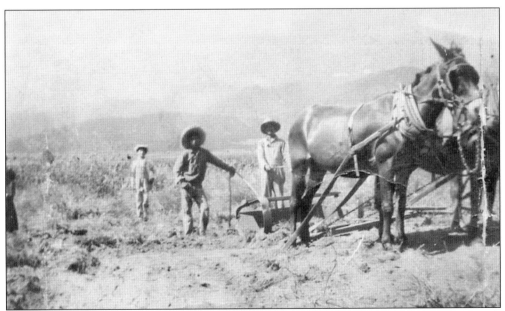

JOSE VALDEZ AND SONS. Jose Valdez and sons are hard at work on the Meyer's Verdemont Ranch in what is now the northwest section of the city. The photo is undated, but was taken sometime between 1916 and 1926, the years that the Valdez family lived up there. (Courtesy of Luis Macias.)

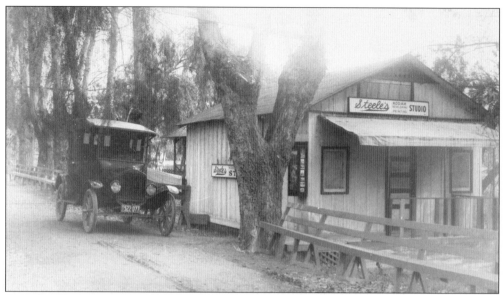

STEELES' PHOTO SERVICE. During the 1920s, Walter Steele started a small photo agency at Urbita Springs Park (featured in this picture) and became a household name for local historians. In addition to assuming the copyrights of previous photographers in the area, his company took pictures of seemingly just about every view in the valley. Many of the photographs used in this book were taken by Steele's Photo Service. Eventually, he and his wife Beatrice moved their business to "D" Street. (Courtesy of San Bernardino Public library.)

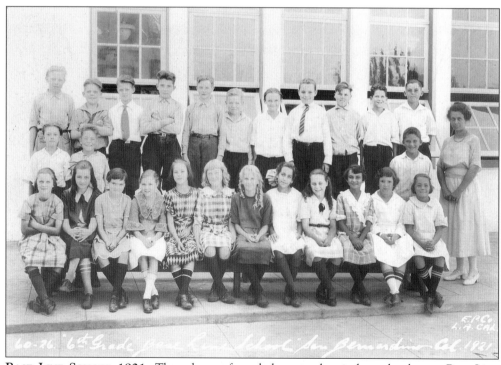

BASE LINE SCHOOL 1921. These happy faces belong to the sixth grade class at Base Line School in 1921. (Courtesy of San Bernardino Historical Society.)

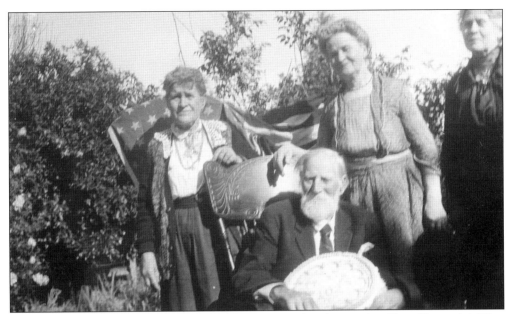

JOSEPH HANCOCK. Joseph Hancock is a happy man as his three girls—Nora Hancock Miller, Jerusha Hancock Tyler, and Lucina Hancock Lord—surround him on his 99th birthday. The photo was taken on May 7, 1921. A true pioneer, "Grandpa Hancock" arrived in San Bernardino by covered wagon in 1854 and passed away in 1924 at the ripe old age of 102. (Courtesy of San Bernardino Historical Society.)

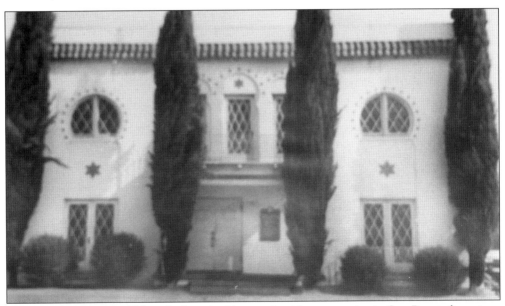

JEWISH SYNAGOGUE. Although there had been a Jewish community in San Bernardino since the 1850s, the congregation did not have a permanent synagogue until this building was erected at 847 "E" Street in 1921. Up until the next decade, Congregation Emanu El (as it was named) was the only synagogue between Pasadena and Phoenix and it brought Jews together from throughout San Bernardino, Riverside, and the eastern part of Los Angeles Counties. (Courtesy of Congregation Emanu El.)

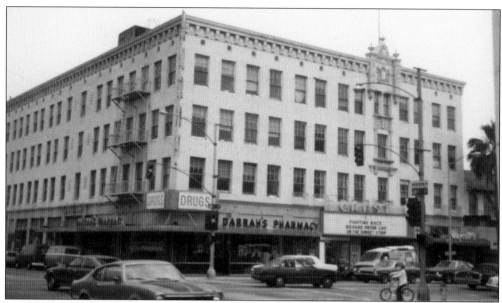

PLATT BUILDING. This is the Frank C. Platt Building, which was built in 1924. A year later, 17-year-old Lyndon Baines Johnson ran the elevator for a while during the summer. Inside this edifice for the next half century were offices, the West Coast Theater (later known as the Crest), and various little shops. This photo was taken in 1982. The building was torn down during the mid-1990s to make way for a new high rise Cal Trans building. (Courtesy of author.)

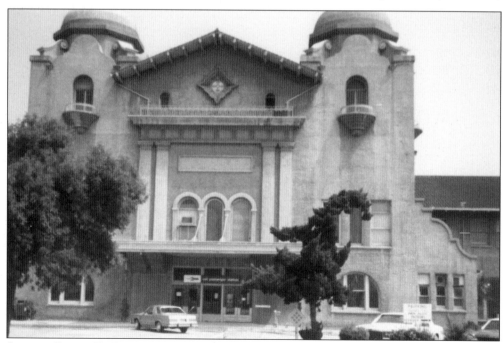

SECOND SANTA FE DEPOT. Two years after the 1886 wooden station burned in a spectacular fire, a new one was built in 1918 on the north side of 3rd Street near "J" Street. At one time this facility housed more than 5,000 employees—the largest of its kind west of the Mississippi. (Courtesy of San Bernardino Historical Society.)

STEAM ENGINE #3751. Built in 1928, this steam locomotive was restored into "running" condition by members of the San Bernardino Railroad Historical Society. It will be housed inside a rail museum adjacent to the 1918 Santa Fe Depot upon restoration which will, hopefully, be completed by 2005. (Courtesy of San Bernardino Historical Society.)

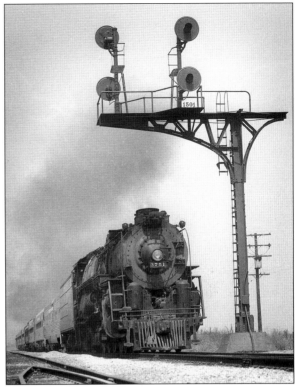

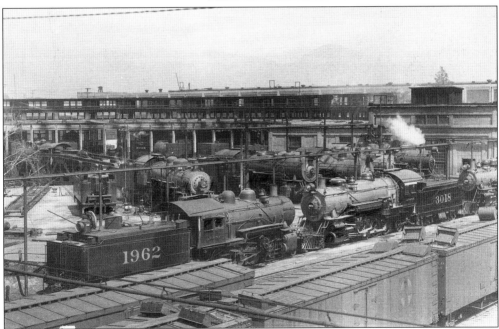

SANTA FE ROUNDHOUSE. This 1922 scene is of the Santa Fe Roundhouse, which was built around the turn of the century. During the early 1990s the Santa Fe system was downscaling its operations and the round house was one of several structures to meet the wrecking ball. (Courtesy of San Bernardino Historical Society.)

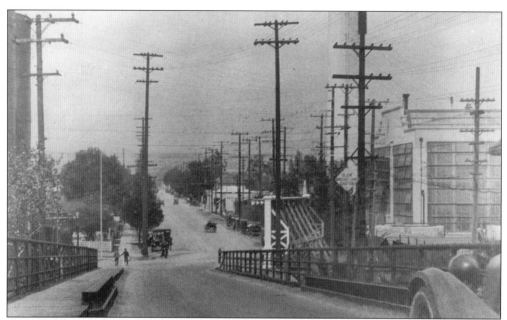

THE OLD VIADUCT. This is the old Santa Fe viaduct looking northbound along Mt. Vernon Avenue in 1922. The tall smoke stack is still standing today. (Courtesy of San Bernardino Historical Society.)

FUN AT CAMP CAJON. A fun place for San Bernardino residents for get -togethers during the 1920s and 30s was at Camp Cajon, located about 15 miles from town in the Cajon Pass. That's local civic leader John Brown Jr. wearing the crown and about to perform some type of fun ceremony. The popular rest stop and picnic area was wiped out during the terrible flood of 1938. (Courtesy of San Bernardino Historical Society.)

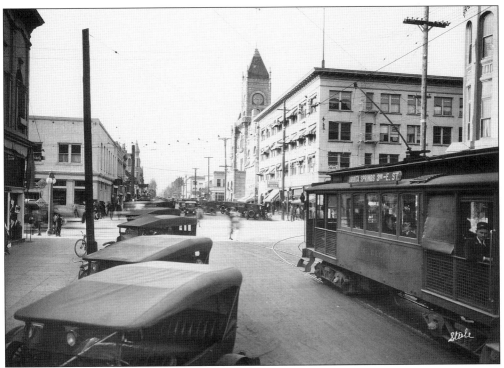

"E" STREET IN 1925. This is a view of "E" Street looking north from 3rd in 1925. One of the chief means of transportation around town was the electric trolley like the one featured here. (Courtesy of San Bernardino Historical Society.)

CAJON SCHOOL. Cajon School was a two-room (later expanded to four) native rock-constructed elementary school located in the San Bernardino outskirts community of Devore. Built in 1924, it took the place of four one-room facilities spread out in the foothills and Cajon Pass and was part of the San Bernardino City Unified School District until closing its doors in 1968. (Courtesy of author.)

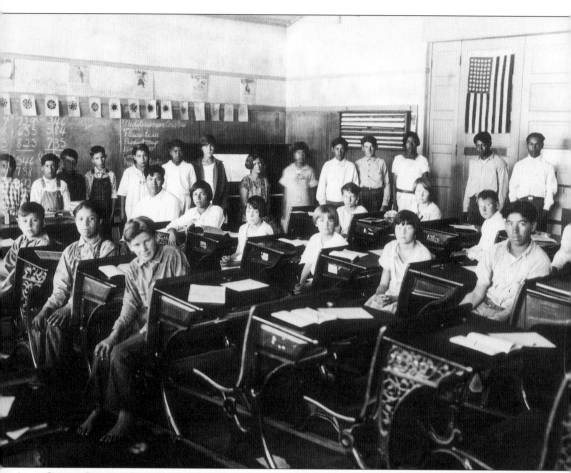

CAJON SCHOOL INTERIOR. This great shot of Melissa Roesch's 4-6 combination class at Cajon School in 1927 gives a good idea what a country school looked like. Note that not every student could afford shoes back then. (Courtesy of author.)

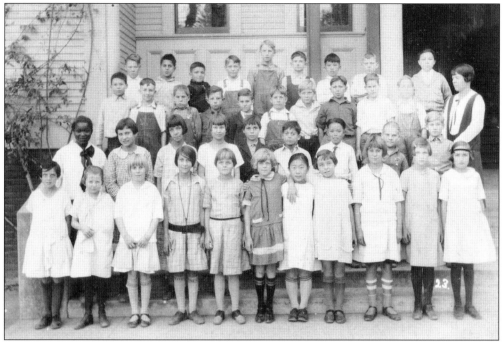

1925 FIFTH GRADE CLASS. This is the fifth grade class at Fourth Street School in 1925, which was taught by Miss Lindsey. In the top row on the far right is future civic leader, Bing Wong, who recently arrived from China. The donor of the photo, Masako Hirata, is in the front row, seventh from the left. (Courtesy of Masako Hirata.)

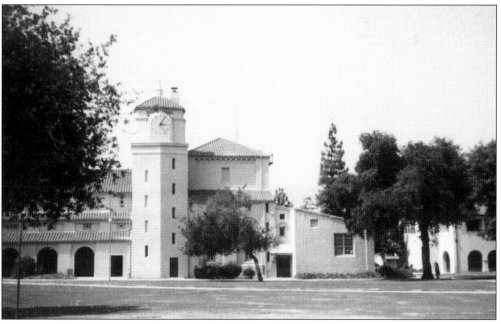

SAN BERNARDINO VALLEY COLLEGE. San Bernardino Valley College has been a popular and well attended junior college since 1926. This is a picture of the auditorium that was built that first year. (Courtesy of San Bernardino Public Library.)

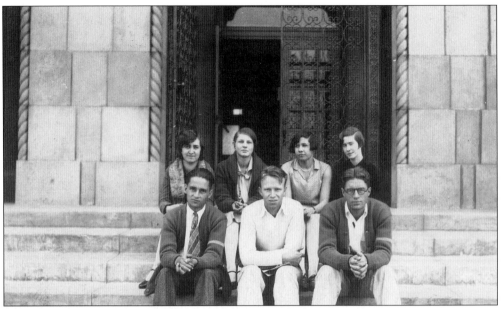

VALLEY COLLEGE EXECUTIVE COMMITTEE. This scholarly crew made up the executive student body committee at San Bernardino Valley College for 1927–1928. Walter Gee (center) was the student body president. (Courtesy of San Bernardino Historical Society.)

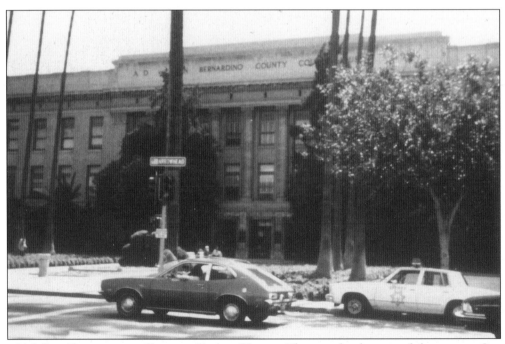

1926 SAN BERNARDINO COUNTY COURT HOUSE. This stately photo is of the present San Bernardino County Court House that was built in 1926. Current plans are to build a new courthouse nearby, but continue to use this old facility (which is on the National Register of Historic Places) in some court-related capacity. (Courtesy of author.)

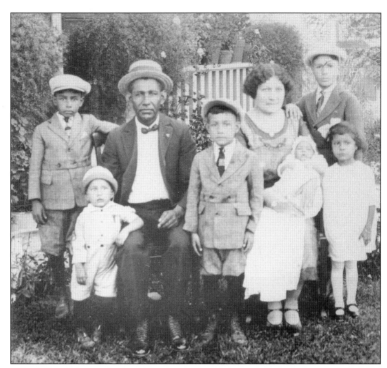

MANUEL GOMEZ FAMILY. This is the Manuel Gomez family in 1926. Ten-year-old Manuel, who is the photo donor, is standing on the right side. The picture was taken at 628 W. Pico Street. (Courtesy of San Bernardino Public Library.)

CALIFORNIA HOTEL. The beautiful California Hotel was a high class place for some fifty years. Many celebrities and dignitaries stayed a night or two. At one time, radio station KFXM had a studio there. One of its announcers doubled as a singer. His name was Ernie Ford—later to be famous as "Tennessee Ernie." Built in 1927, the hotel was torn down in 1985. (Courtesy of San Bernardino Historical Society.)

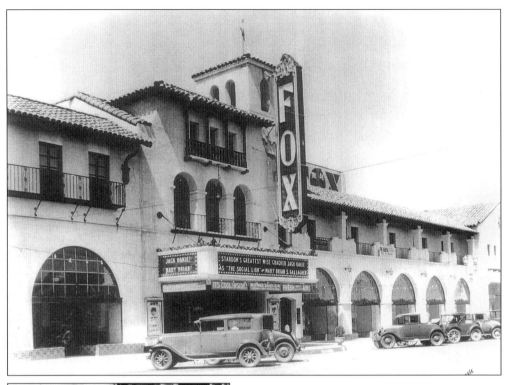

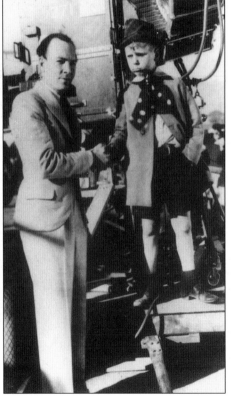

FOX THEATER. The Fox Theater was one of three movie places in San Bernardino for previewing films for major Hollywood studios during the '20s, '30s, and early '40s. This town was the movie "pre-view capital"—where movie celebrities would take a peek at their latest gem before releasing it to the general public. (Courtesy of San Bernardino Historical Society.)

JACKIE COOPER AT THE FOX. Jackie Cooper was a famous child star during the 1930s. He is posing with Everet Sharp, the manager of the Fox Theater. (Courtesy of San Bernardino Historical Society.)

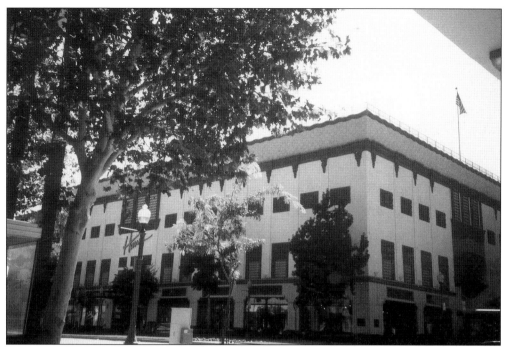

Harris Building. Philip, Herman, and Arthur Harris built this beautiful edifice in 1927 at 3rd and "E" Streets. Harris Company was a mainstay in this town until closing down during the late 1999. During the long interim, the store featured fine clothing, upscale merchandise, and many fond shopping memories. (Courtesy of author.)

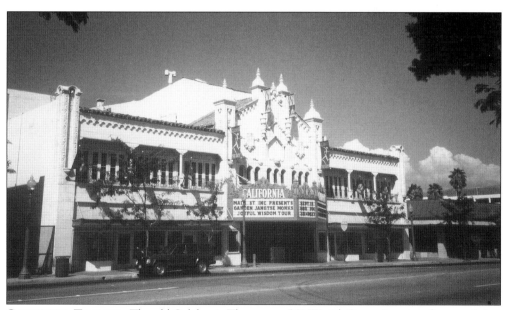

California Theater. The old California Theater on 562 W. 4th Street is among five remaining Art Deco theaters in California. This beautiful 1,760-seat building began as a vaudeville and movie theater in 1928. Legendary humorist Will Rogers made his last public appearance there before his fatal airplane crash in 1935. Today the theater is a performing arts house. (Courtesy of author.)

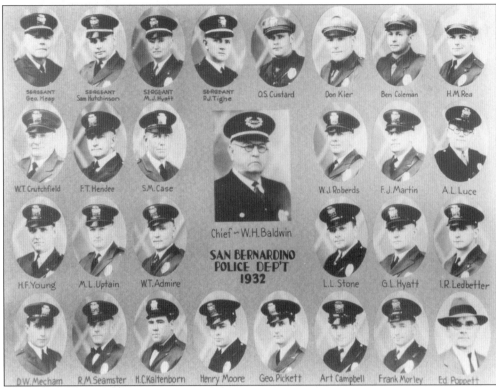

SAN BERNARDINO POLICE DEPARTMENT 1932. These brave men made up the San Bernardino Police Department. This photo, showing the pride of our city, was taken in 1932. The police chief was W.H. Baldwin. (Courtesy of San Bernardino Historical Society.)

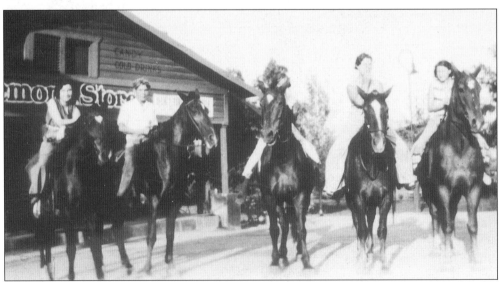

MEYER KIDS IN VERDEMONT. In this fun 1930s picture, several of the Meyer family kids are showing off their prowess on horseback. Alma Meyer Heap, the donor of this photo, is riding on the far right. The building in the background is the Verdemont Store. Verdemont was an unincorporated community for years but is now part of San Bernardino. (Courtesy of author.)

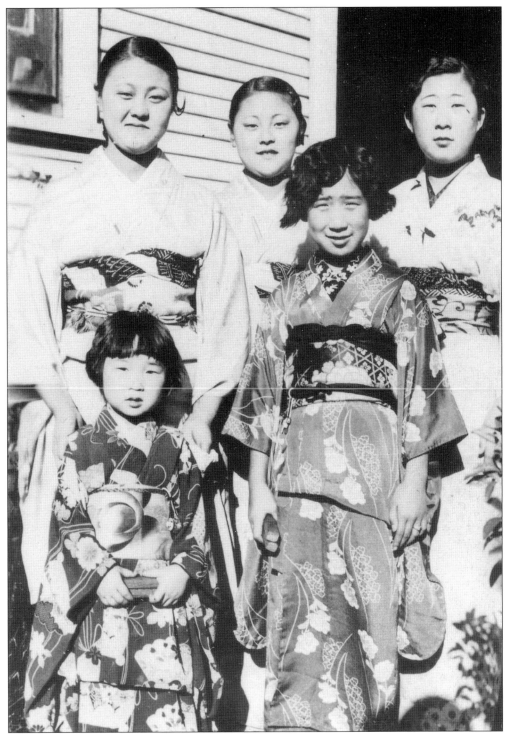

DOLL FESTIVAL DAY 1934. This 1934 photo was taken on Doll Festival Day in front of the Japanese Christian Church. In the front row are Phyllis and Edith Hirata. In the back row, from left to right, are, Mary and Helen Hayamizu and Masako Hirata. (Courtesy of Masako Hirata.)

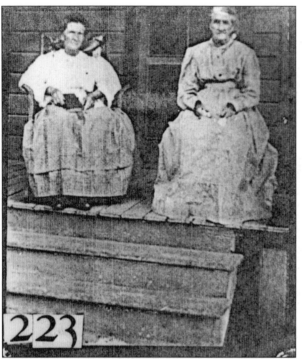

RELAXING ON THE FRONT PORCH. Annie (Cadd) Alexander (left) and her friend, Emma Stachbury, are pictured sitting outside on Annie's front porch at her 7th Street ranch a short time before her death in 1931 at the age of 89. (Courtesy of Blanche Tompkins.)

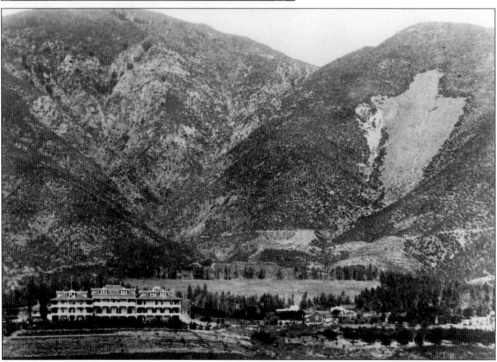

OLD ARROWHEAD SPRINGS HOTEL. Before the arrival of the white man, Arrowhead Springs, located in the foothills above San Bernardino, was used as ceremonial grounds for the local Indians. With new arrivals, the area made the transition into a popular Hollywood celebrity's retreat during the 1930s and early 1940s. (Courtesy of San Bernardino Historical Society.)

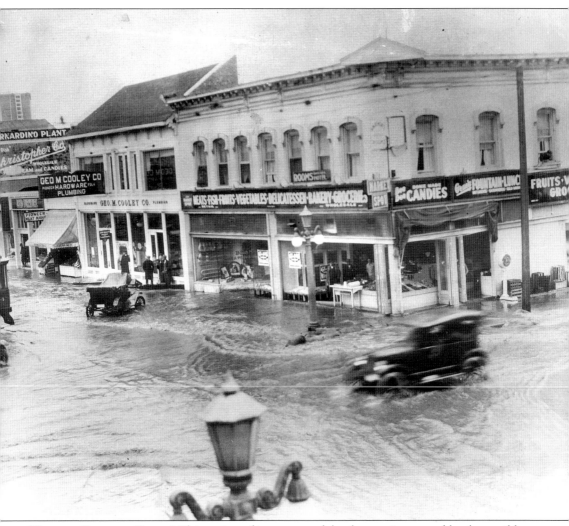

WHEN IT RAINS IT POURS! This a view of just a part of the devastation caused by the terrible flood of 1938. Destruction occurred all over the south land. This photo was taken at 3rd and "D" Streets. (Courtesy of San Bernardino Historical Society.)

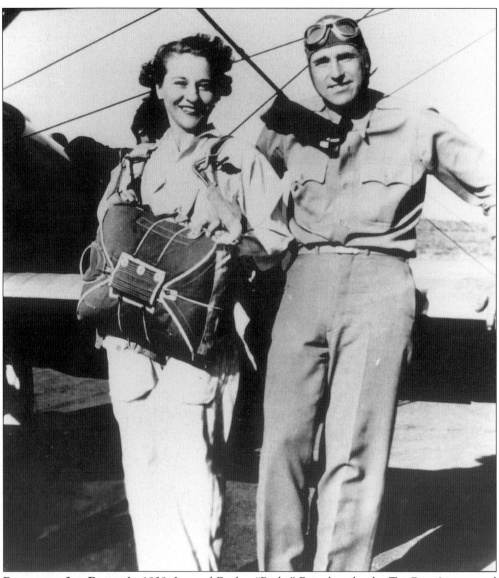

PINKY AND JOE BRIER. In 1939, Joe and Evelyn "Pinky" Brier bought the Tri-City Airport and made it their home for the next 40 years. The dynamic duo ran a flying school, opened up a restaurant, and transported passengers all over the southwest. (Courtesy of Evelyn "Pinky" Brier.)

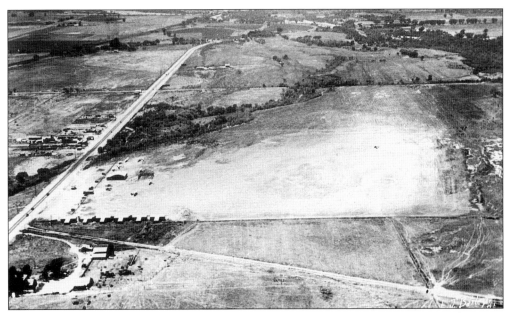

TRI-CITY AIRPORT. Located southeast of town, Tri-City Airport was started in 1927 by W.H. Lines. Except for the few years when the military used the facility for wartime efforts during WWII, Tri-city was a public air facility into the 1970s.

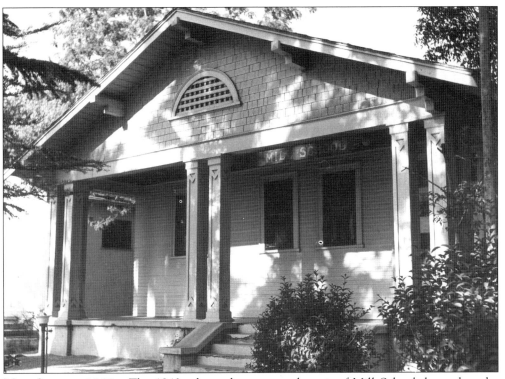

MILL SCHOOL 1940S. The 1940s photo that you see here is of Mill School, located at the corner of Waterman Avenue and Central. The predominantly African-American community was known as Valley Farms. (Courtesy of Dorothy Inghram.)

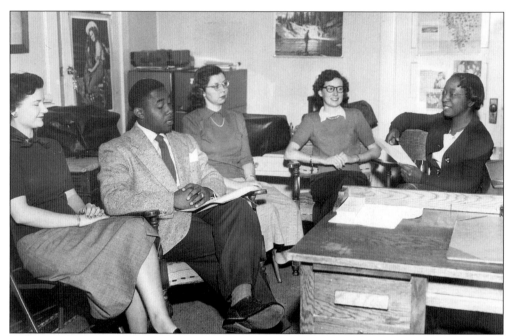

DOROTHY INGHRAM 1940S. This 1940s picture shows Dorothy Inghram (seated on the right) when she was principal of Mill School. Miss Inghram became the first African American teacher in San Bernardino in 1941 and soon became the first African-American administrator in the entire state of California. (Courtesy of Dorothy Inghram.)

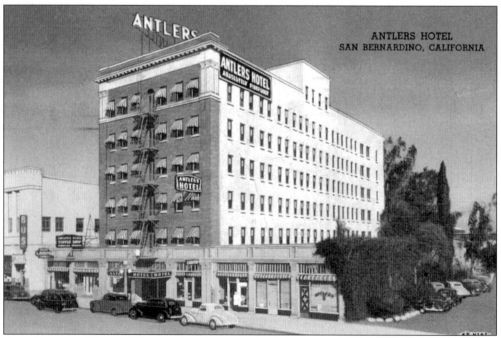

THE ANTLERS HOTEL. This is a 1940s postcard of the popular Antlers Hotel in downtown San Bernardino. It was one of several such thriving businesses in the city during the first half of the 20th century. (Courtesy of author.)

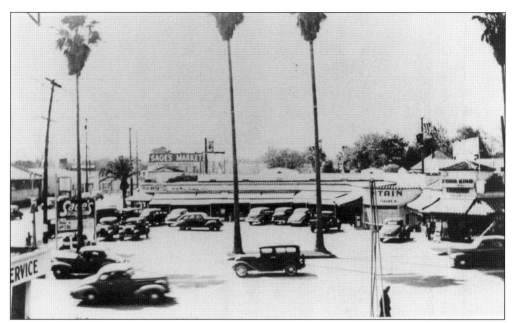

ORIGINAL SAGE'S MARKET. Milton R. Sage had shared an open-air market with several other retailers at "E" Street and Base Line in 1937. (Courtesy of San Bernardino Public Library.)

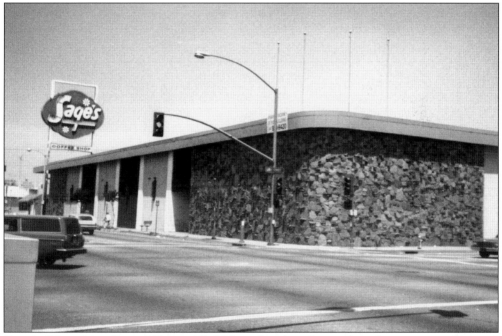

SAGE'S "ONE STOP SHOP." Eventually Milton Sage bought out the other open air sellers and revolutionized retailing. He started the "one stop shopping experience", a place where customers could buy clothing, jewelry, produce, hardware appliances, flowers, and stop for a bite to eat inside their coffee shops (well known for the strawberry pies). This photo shows the Sage's store (one of six) at "E" and Base Line Streets soon after closing its doors for the last time in 1973. (Courtesy of author.)

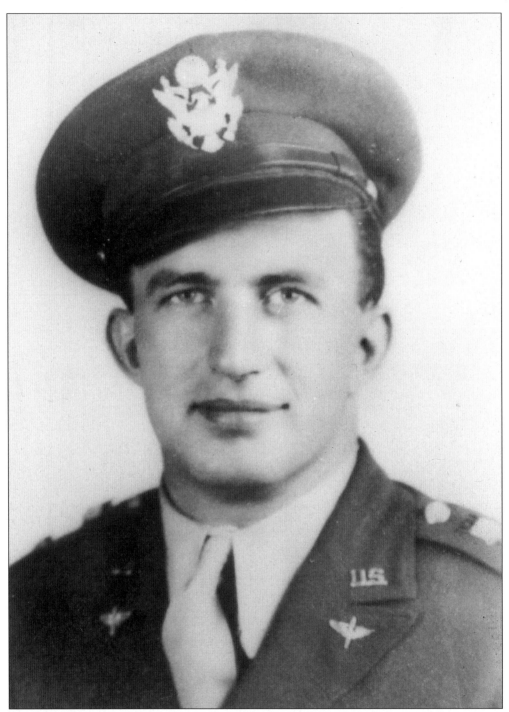

LELAND NORTON. San Bernardino native Leland Francis Norton was in the U.S. Air Force during World War II. On May 27, 1944, he was killed in action over Amiens, France. He and a crew of three were flying an A-20 bomber, dive-bombing to attack a target, when their plane was hit. In 1950, the San Bernardino Air Material Command was renamed Norton Air Force Base in honor of their native son.

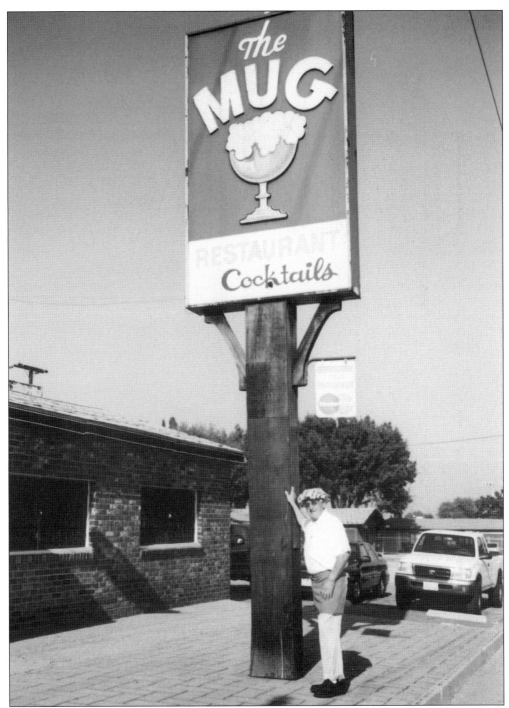

THE MUG. In 1948 Mary Trozera, along with her sons Tony and Vince, opened The Mug at the corner of Muscott Street (now Medical Center Drive) and Highland Avenue. This popular eatery has been dishing out fine Italian food ever since. When this photo was taken in August 2002, Tony Trozera (featured here) mentioned that the Mug was the first restaurant to feature homemade pizza on its menu. Bon appetite! (Courtesy of author.)

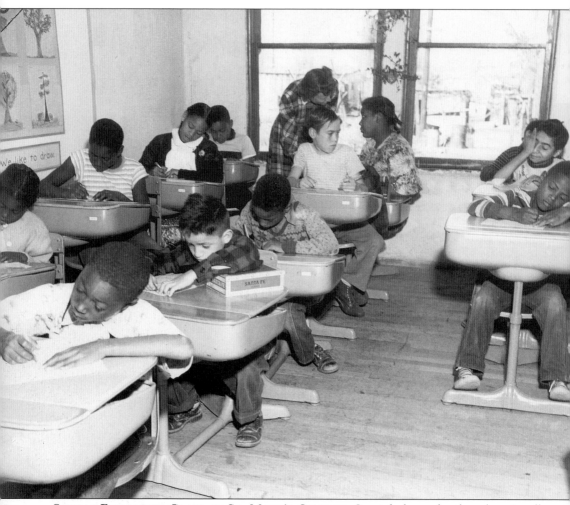

SPECIAL EDUCATION CLASS AT ST. MARK'S CHURCH. Special classes for the educationally challenged were in their infancy when this 1940s photo was taken. Shown here are some of the special education students that were enrolled at Mill School, but for lack of space, they attended class at nearby Saint Mark Baptist Church. (Courtesy of Dorothy Inghram.)

THE FIRST MCDONALD'S RESTAURANT. After running a successful barbecue restaurant in San Bernardino for several years, Richard and Maurice McDonald decided to focus on speed, lower prices, and volume. And on December 12, 1948, they opened the original McDonald's restaurant featuring their "Speedee Service System," selling 15¢ hamburgers and 10¢ fries. In 1961 the brothers sold their franchise to Ray Kroc. Today there are thousands of McDonald's restaurants throughout the U.S. and scores of other countries. (Courtesy of McDonald's Museum.)

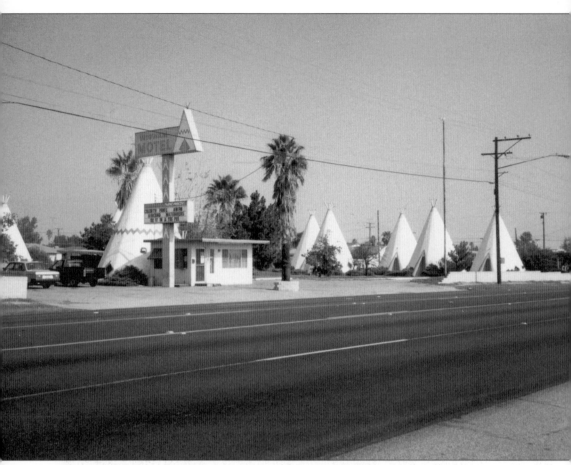

WIGWAM MOTEL. Driving west along old Route 66 Highway (locally known as Foothill Boulevard) as you are about to leave San Bernardino, its hard to miss the 19 stucco teepees which provided shelter for exhausted motorists for many years beginning in the late 1940s and ending with the advent of Interstate 10 during the '60s. The "Wigwam Motel" is still in operation and a fond reminder when times were a bit simpler than today. (Courtesy of author.)

Four
DAWN OF A NEW ERA
1951–PRESENT

NEW MILL SCHOOL DEDICATION. The dedication of the new Mill School, as you can see in this 1951 photo, drew a big crowd. The new, much larger facility was well received as a place of pride and beauty. (Courtesy of Dorothy Inghram.)

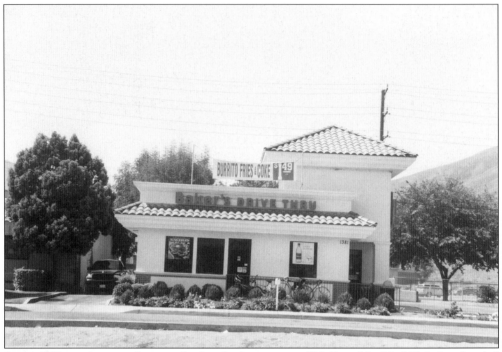

BAKER'S RESTAURANT. As a regular fast food customer of McDonald's, Neil T. Baker decided to open one of his own. He called it, not surprisingly, "Baker's." Three years later, his popular San Bernardino Valley restaurants, such as the one featured here on Kendall Drive, were the first in the nation to use the "Twin Kitchen" concept—an offering of both American and Mexican entrees. (Courtesy of author).

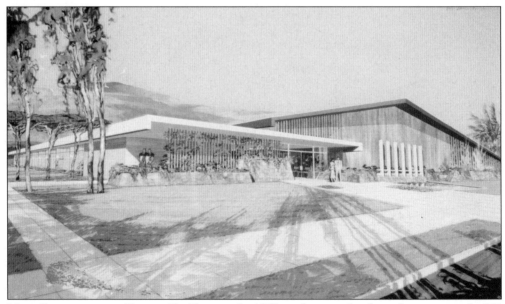

NEW CONGREGATION EMANU EL TEMPLE. In 1952, with a membership of approximately 150 Jewish families, a new synagogue was constructed at 35th and "E" Streets. Today, there are close to 500 households affiliated with Congregation Emanu El. (Courtesy of Congregation Emanu El.)

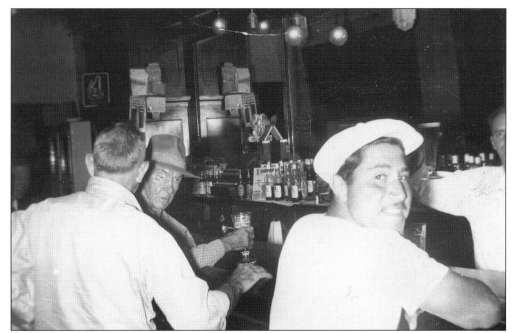

LORENZO VALDEZ AT THE CARTA BLANCA. Lorenzo Valdez is relaxing in the side bar at the Carta Blanca, a popular restaurant on Mt. Vernon Avenue between Spruce and 6th Streets during the early 1950s. (Courtesy of Luis Macias.)

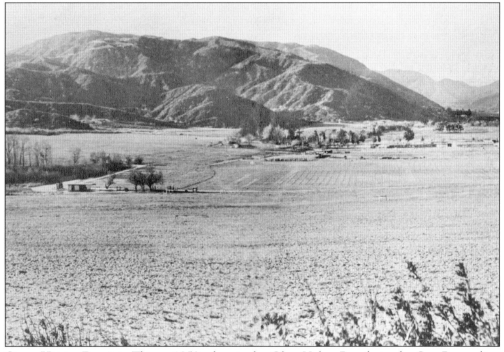

GLEN HELEN RANCH. This *c.* 1950s shot is the Glen Helen Ranch in the San Bernardino outskirts community of Devore. In 1963 the property was bought out by the park service and turned into Glen Helen Regional Park. (Courtesy of Glen Helen Regional Park.)

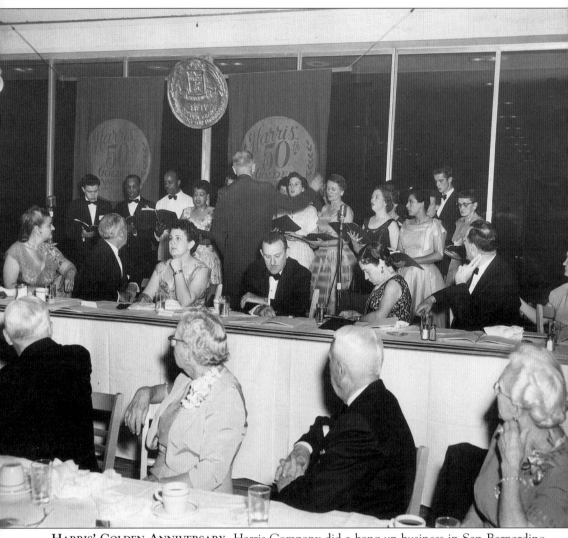

HARRIS' GOLDEN ANNIVERSARY. Harris Company did a bang up business in San Bernardino from 1905 (inside a small dry goods store) until the late 1990s when its popular clothing and quality merchandise business came to an end. This photo of the gala in 1955, boasts of the company's golden anniversary in town. (Courtesy of San Bernardino Historical Society.)

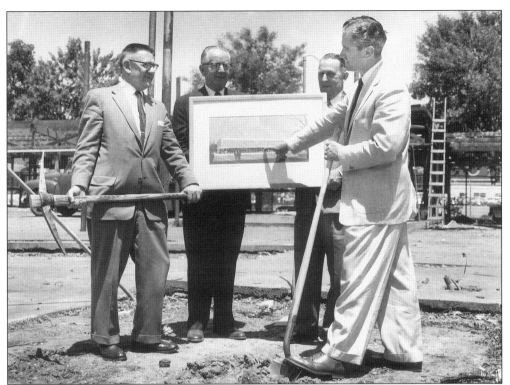

GROUND BREAKING CREW. On May 14, 1956, the official ground breaking for the San Bernardino Division Office took place. Posing here are, left to right: William P. Hand (division manager), J.C. Sloan (president of the chamber of commerce), R.R. Blackburn (vice president), and Raymond Gregory (mayor of San Bernardino). (Courtesy of San Bernardino Historical Society.)

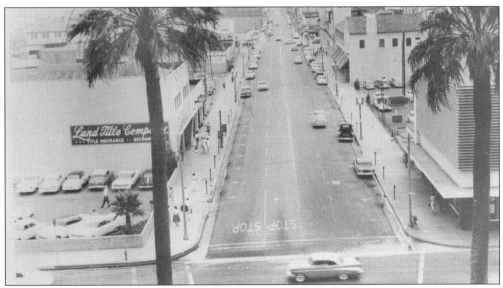

COURT STREET IN 1959. Downtown San Bernardino had come a long way since the city's founding a century earlier. This view of Court Street was taken c. 1959. (San Bernardino Public Library.)

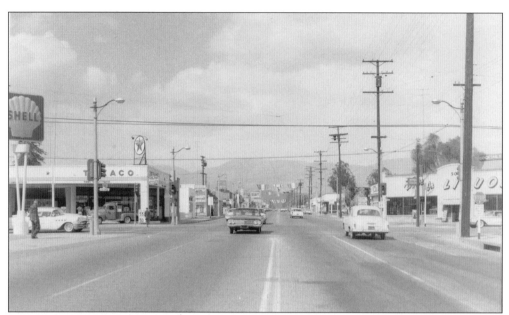

MT. VERNON AVENUE IN 1963. This 1963 photo is looking along Mount Vernon Avenue, located in the western section of the city. San Bernardino was a popular Route 66 destination back then and Mt. Vernon was an integral part of the Mother Road. (Courtesy of San Bernardino Public Library.)

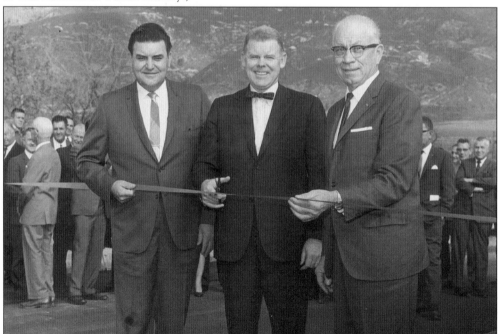

CAL STATE S.B. RIBBON CUTTING. This is the official ribbon cutting celebration for the new California State College (now university) in the foothills in north San Bernardino. Construction began in January 1965, and classes started up the following fall semester. Pictured here, left to right, are: San Bernardino mayor Al C. Ballard; John Phau, president of the Cal State; and Paul Young, county supervisor. (Courtesy of San Bernardino Historical Society.)

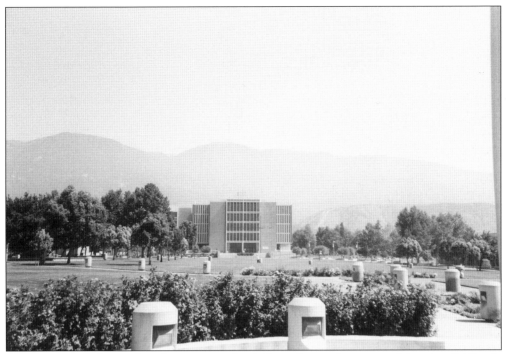

CAL STATE S.B. Located in the mountain foothills in the northern part of the city, California State University, San Bernardino, got its start in 1965. At first, there were only a couple hundred students, but this highly acclaimed institution for higher learning will be closing in on 20,000 before long. (Courtesy of author.)

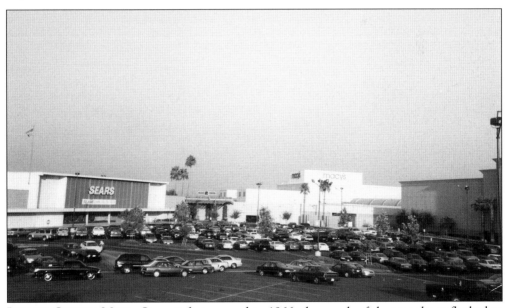

INLAND CENTER MALL. Since it first opened in 1966, thousands of shoppers have flocked to the classy Inland Center Mall. Located at the site of the old Urbita Springs Park west of "E" Street and south of Mill Street, the main anchor stores are Sears Roebuck, Robinson-May, Macy's, and Gottschalks. (Courtesy of author.)

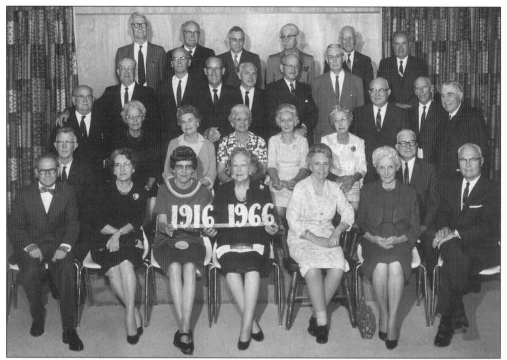

SBHS CLASS OF 1916, 50TH REUNION. The happy folks from San Bernardino High School's class are posing in this picture for their 50th class reunion in 1966. (Courtesy of San Bernardino Historical Society.)

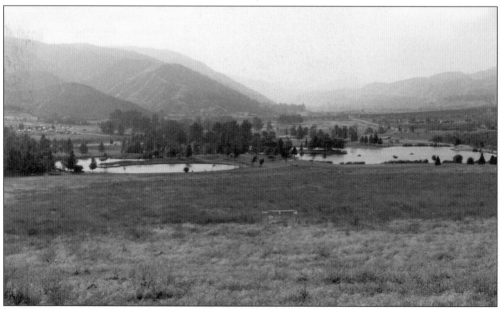

GLEN HELEN REGIONAL PARK. The scene for so many historical events in the past—an Indian settlement, a stage stop, and a pioneer ranch, to name a few—this area was taken over by the park service in 1963. The name became Glen Helen Regional Park. The photo was taken during the late 1960s. (Courtesy of Glen Helen Regional Park.)

RABBI FELDHEYM. Rabbi Norman F. Feldheym was a great leader in the San Bernardino area for many years. He served as the leader of Congregation Emanu El from 1937 until 1971 and as Rabbi Emeritus from 1971 until his death in 1985. (Courtesy of Congregation Emanu El.)

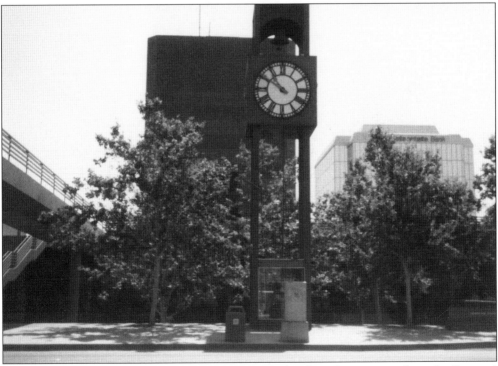

COURT HOUSE CLOCK. This old clock on the east side of "E" Street across from the Carousel Mall was once mounted in the tower of the 1893 Court House. It was moved to its present location in 1973. (Courtesy of author.)

THE CASTAWAY. One of the most popular restaurants in San Bernardino County for fine dining is the beautiful Castaway Restaurant, which is located on top of Little Mountain in the north part of town. With wonderful food and a great view of the surrounding valley, this has been around since 1971. Getting ready for Mother's Day in this 1995 photo are the author, his wife Linda, and son Jay. (Courtesy of the author.)

CAROUSEL MALL. This is the entrance of the popular Carousel Mall, located between Harris Company (left) and the Andreson Building at 295 North "E" Street. The main anchor for this downtown retail center is J.C. Penny's, a longtime mainstay in the San Bernardino area. (Courtesy of author.)

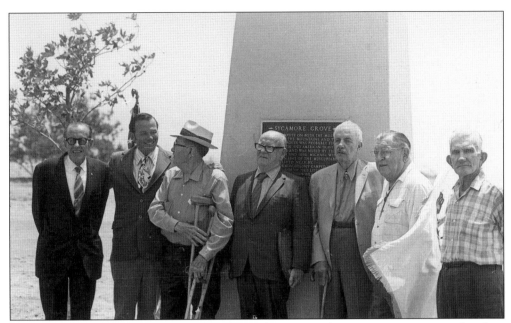

NEW SYCAMORE GROVE MONUMENT. Forty-five years after a monument was placed at Sycamore Grove commemorating the camping spot for the Mormon families, the marker became so vandalized that a replacement had to be made. In 1972, a new Sycamore Grove monument was erected by the San Bernardino Pioneer Society, inside the confines of Devore's Glen Helen Regional Park in 1972. Standing during the dedication ceremony are Christian R. Harris, Mayor W.R. "Bob" Holcomb, Robert E. Jackson, Earl Buie, L. Burr Belden, Donald Van Luven Sr., and John Wing. (Courtesy of San Bernardino Historical Society.)

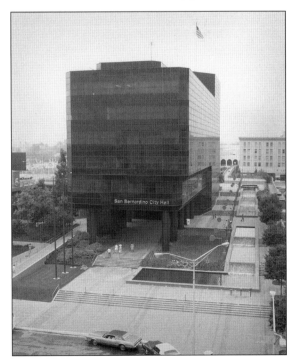

1973 CITY HALL. This handsome new San Bernardino City Hall was opened in 1973 at the corner of 3rd and "D" Streets. (Courtesy of San Bernardino Historical Society.)

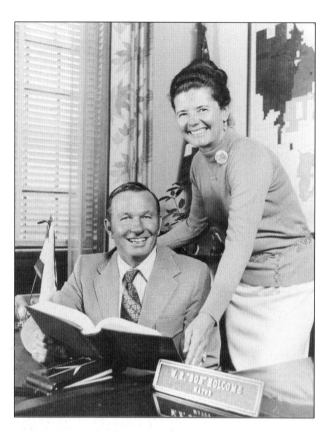

MAYOR BOB AND PENNY HOLCOMB. Civic leader W.R. "Bob" Holcomb is a product of a colorful pioneer family, one whose influence in San Bernardino has been felt since the 1860s. As mayor of this city for 18 years, longer than any other before or after, Holcomb served from 1971 until 1985 and again from 1989 to 1993. Here is seated at his desk in the mayor's office with his wife, Penny. (Courtesy of San Bernardino Public Library.)

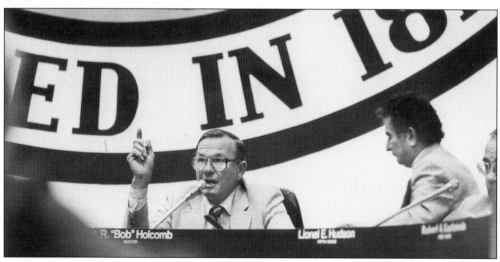

MAYOR HOLCOMB AT A MEETING. In this c. 1980 photo, "Mayor Bob" is defending a major project. That's 1st ward councilman, Robert Castaneda, to his right. (Courtesy of San Bernardino Public Library.)

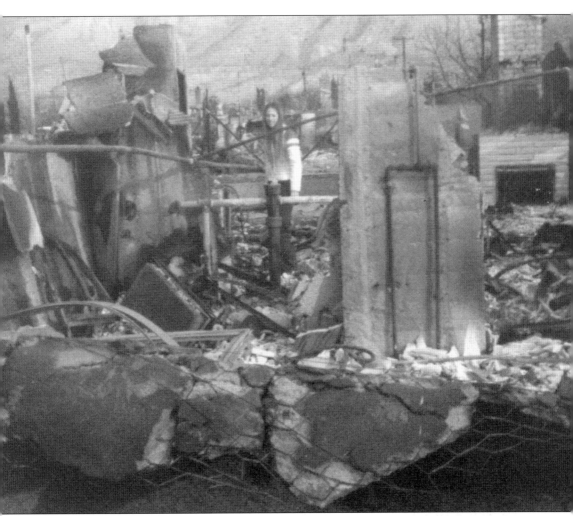

PANORAMA FIRE. In this somber photograph, the author's sister, Kathy (Cataldo) Lee looks over what remained of our parents' home on 5435 N. Stoddard Avenue. This resulted in the devastating Panorama Fire of November 24, 1980. The six-day blaze, the worst in San Bernardino County history, scorched nearly 24,000 acres, left 4 dead, 284 homes completely destroyed and another 49 damaged, and 64 other structures obliterated or charred. Like many neighbors, our parents built a new home on the same location. They still happily live there today. (Courtesy of author.)

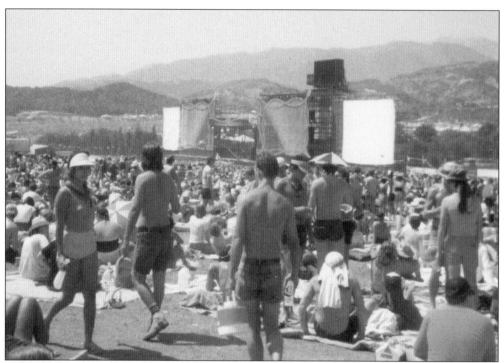

"US" FESTIVAL 1982. Billed as the largest multi-day outdoor rock concert since Woodstock, the "US" Festival came to Glen Helen Park in the outskirts community of Devore over Labor Day weekend in 1982. Several hundred thousand rock fans (including the author) came out to see well known bands like The Police, Tom Petty, Fleetwood Mac, Pat Benatar, The Kinks, and Jackson Browne. It was a wild and crazy three days. (Courtesy of author.)

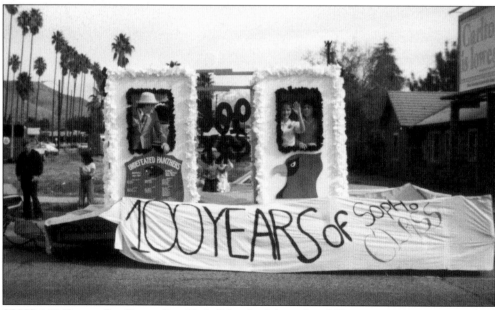

SBHS 100 YEARS. San Bernardino High School celebrated its 100 anniversary in town in 1983. Featured here is one of the floats involved in the celebration parade. (Courtesy of author.)

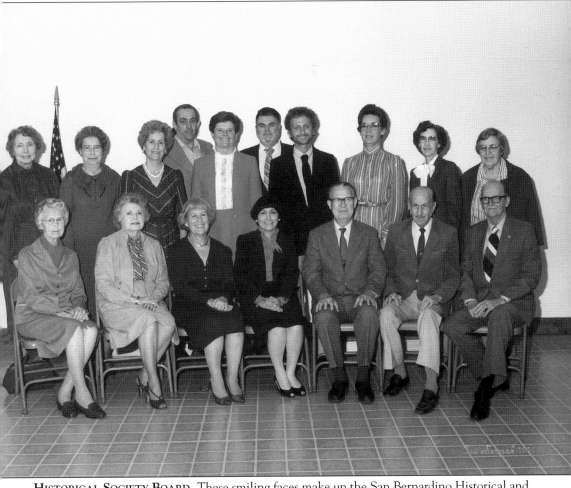

HISTORICAL SOCIETY BOARD. These smiling faces make up the San Bernardino Historical and Pioneer Society's Board of Directors for 1984. Pictured, from left to right, are: (back row) Esther Clay, Beryl Holcomb, Louise Torta, Fred Ratzlaff, Penny Holcomb, Lyle Fowler, Nick Cataldo (author), Johnnie Ralph, Mildred Hudson, and Gertrude O'Dell; (front row) Iva Harris, Thelma Newman, Eleanor Isenberg, Thelma Press, David Wood, Mel Hocker, and Fred Holladay. (Courtesy of author.)

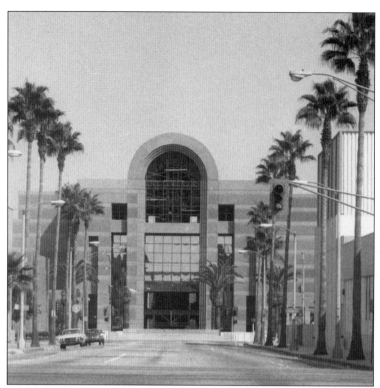

1983 S.B. Co. GOVERNMENT CENTER. This photo was taken shortly after the handsome, new San Bernardino County Government Center was built in 1983. This building is a real work of art—a tall arch over the main entrance and pyramid style design are a striking site. The beautiful inside lobby features a two-story rotunda filled with many kinds of artwork depicting the history of the county. (Courtesy of San Bernardino Historical Society.)

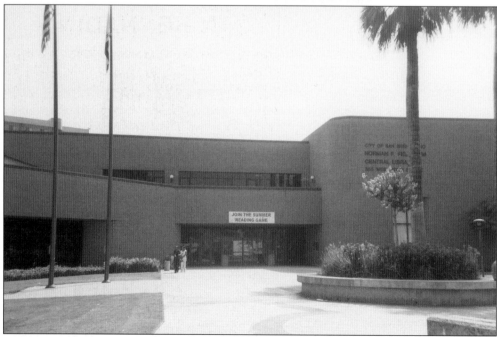

NORMAN FELDHEYM LIBRARY. Named after one of the most influential civic leaders of the 20th century, the Norman Feldheym Central Library has been serving the reading public since 1985. One of the key features of this wonderful library is the California Room, which is one of the best local history resource facilities in the state of California. (Courtesy of author.)

ED JOHNSON. Charles E. "Ed" Johnson was a civil engineer extraordinaire in San Bernardino during the 1920s and '30s, helping to bring about many of the first street lights, paved roads, and bridges in town. He is sitting for this photo in 1985 and passed away five years later at the ripe old age of 100. (Courtesy of author.)

STAN SANCHEZ OF SAN BERNARDINO SPIRIT 1987. Professional baseball reached San Bernardino in 1987. The single-A team was originally known as the "Spirit," but later changed its name to the Stampede. In this photo, long-time baseball coach for the local schools, Stan Sanchez, looks mighty proud to be named one as a coach for the Spirit during the team's initial season.

SAN BERNADINO

STAN SANCHEZ Co.

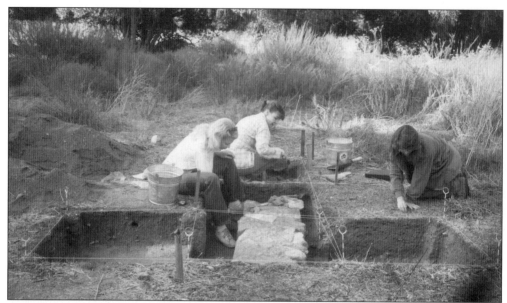

FAIRVIEW SCHOOL SITE. This July 1986 photo shows how this archeology class from Cal State San Bernardino is digging up the past. Dr. Russell Barber and his students are excavating the site of Fairview School, which was located in the foothills north of the university campus. This one-room schoolhouse served the dozen or so farmers' children living in the surrounding area from 1887 until 1899. (Courtesy of author.)

SAN BERNARDINO

PICTURESQUE SAN BERNARDINO. Being centrally located is everything. San Bernardino is the gateway to the popular mountain resort areas of Lake Arrowhead and Big Bear. This postcard was taken in 1988.

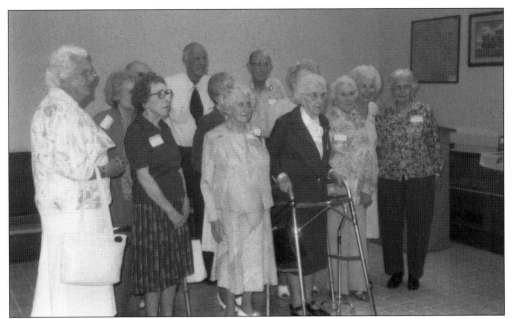

1919 SBHS CLASS REUNION. San Bernardino High School's graduating class of 1919 had a great time when they celebrated their 70th reunion at the San Bernardino Historical and Pioneer Society's Christian R. Harris Meeting Hall in June 1989. Janet Miles, standing third from the left in the front row, celebrated her 101st birthday in April of 2002. (Courtesy of author.)

DAMAGED MOHAVE TRAIL MONUMENT. In January of 1991, damage brought on by vandalism to the 1931 Mohave Trail Monument was discovered. That's Mojave Desert historian John Swisher mixing concrete. (Courtesy of author.)

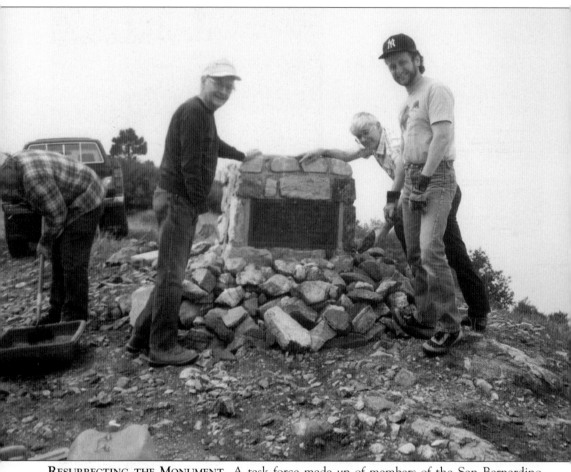

RESURRECTING THE MONUMENT. A task force made up of members of the San Bernardino Historical and Pioneer Society, the Mohave Historical Society, the Friends of the Mojave Road, and the Jedediah Smith Society, got together. Working with concrete mix, tools, water, and a little brawn, the monument was resurrected once again. John Cataldo (author's father) is standing on the left, the author is wearing a baseball cap, and Wayne Heaton is leaning behind the author. (Courtesy of author.)

BILL LEONARD SR. Bill Leonard Sr. is standing next to the author beside the San Bernardino Historical and Pioneer Society's Heritage House on the day he received the "Citizen of the Year Award" for 1994. A retired realtor, Leonard has been strong civic leader in the city for many years. Among his many contributions are serving on the state highway commission and serving as president of the National Orange Show. (Courtesy of John Lowe.)

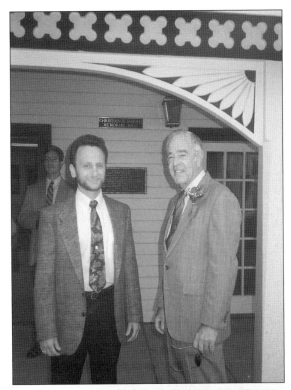

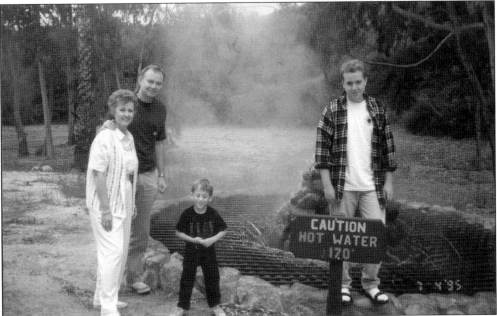

ARROWHEAD HOT SPRINGS. Because of the numerous high temperature geothermal springs seeping from underground, it is little wonder that the Spanish called the San Bernardino Valley "Agua Caliente," meaning hot water. Standing near one of those amazing feats of nature at Arrowhead Springs in July 1995, are, left to right: Elaine and Dr. Ernest Myrick, Jay Cataldo, and Richie Myrick. (Courtesy of author.)

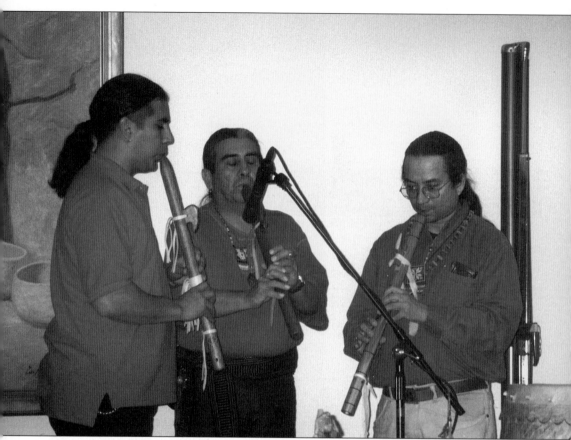

NATIVE AMERICAN FLUTE MUSIC. The San Bernardino Historical and Pioneer Society puts on monthly programs covering various topics on local history free to the public. Native Americans Gary Lemos (center) and Henry Vasquez (right) passionately keep their ancestors' culture alive by coming every year to put on a wonderfully entertaining flute and percussion program. In this 1998 photo, they are joined by a friend and together demonstrate how tribes, such as our local Serrano Indians, performed for various ceremonies. (Courtesy of San Bernardino Historical Society.)

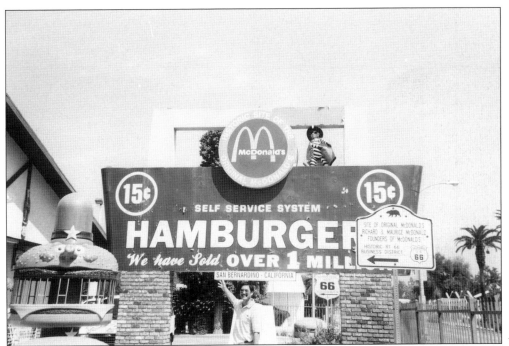

MCDONALD'S/ROUTE 66 MUSEUM 1. This dual purpose museum at the corner of 14th and "E" Streets marks the site of the very first McDonald's Restaurant (1948) in the world as well as housing a wealth of nostalgia from the "Mother Road," which ran right through town. On August 5, 1998, this property was purchased by Albert Okura (standing next to the famous 15¢ Hamburger sign), founder of Juan Pollo Restaurants. (Courtesy of author.)

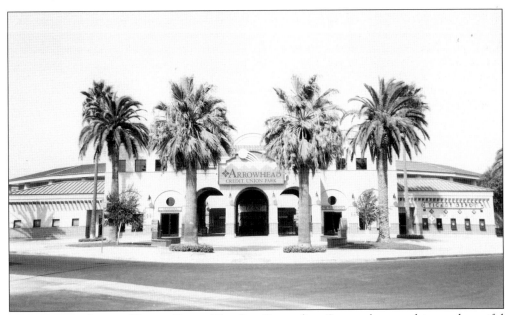

ARROWHEAD CREDIT UNION PARK. The San Bernardino Stampede moved into a beautiful new stadium towards the end of the 1996 baseball season. Originally called the "Ranch," the name has recently changed to Arrowhead Credit Union Park. (Courtesy of author.)

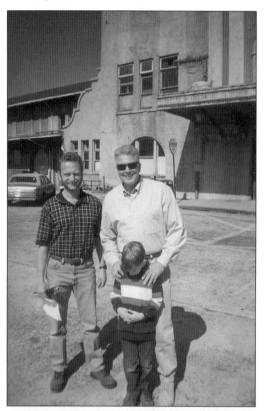

HUELL HOWSER. February 24, 1999, was a big day in San Bernardino. On that day, Huell Howser, host of the popular PBS television shows *California's Gold* and *Visiting with Huell Howser*, came to the historic Santa Fe Depot. Standing to the author's left and behind Jay Cataldo, Howser was here to do a T.V. episode on the history and future restoration plans of the old train station. (Courtesy of John Lowe.)

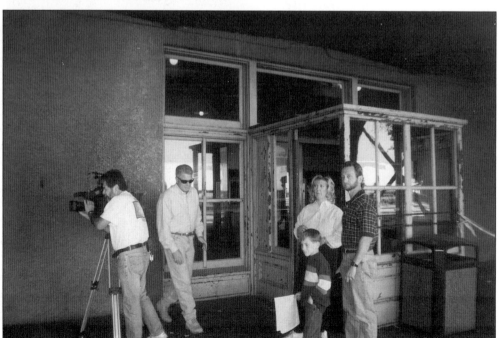

HUELL AND LUIS FILMING. In this photo during the *Visiting with Huell Howser* episode, cameraman Luis Fuerte is working in shot. (Courtesy of John Lowe.)

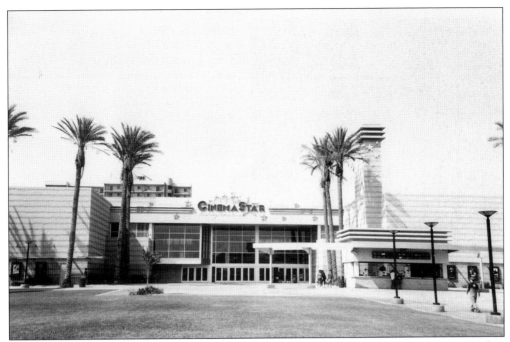

CINEMA STAR THEATER. The 20-screen Cinema Star Theater opened in downtown San Bernardino in December 1999. The stadium seating makes the movie watching experience here a wonderful experience. (Courtesy of author.)

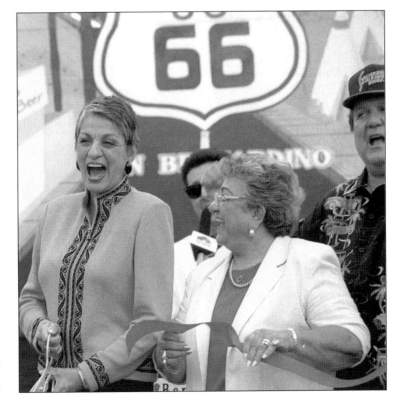

FUN AT ROUTE 66 RENDEZVOUS. San Bernardino mayor Judith Valles (left), Senator Nell Soto (center), and Stater Bros. president and CEO Jack Brown (right) are having a great time at the annual Route 66 Rendezvous in this September 14, 2000, photo. (Courtesy of *The Sun* newspaper.)

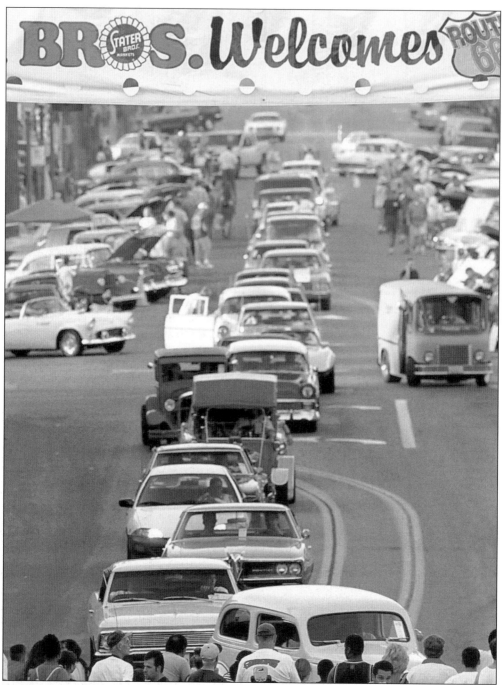

ROUTE 66 RENDEZVOUS. Back in the hey days of the "Mother Road," San Bernardino was a Route 66 town. And for over a decade now, this city has kept that old 1930s-through-1960s nostalgia alive with the annual Route 66 Rendezvous. Each year during a four-day stretch in September, over 2,000 classic cars cruise and then park along the streets of downtown. An estimated crowd of 250,000 turned out on when this photo was taken on September 18, 2000. (Courtesy of *The Sun* newspaper.)

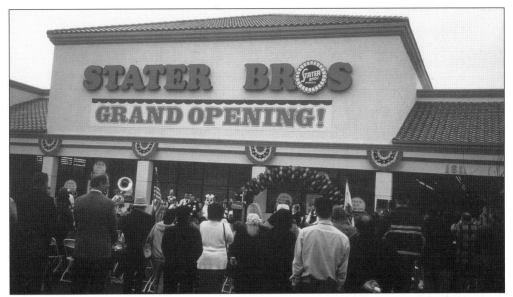

STATER BROS. GRAND OPENING Stater Bros. Markets have been around in Southern California since 1936 when Cleo and Leo Stater started out with a small grocery store in Yucaipa. This gala event photo is of the grand opening for the new Stater Bros. on 40th Street that took place on April 11, 2001. Today there are over 150 stores, mostly in San Bernardino and Riverside Counties. The lucrative chain, under the guidance of CEO Jack Brown, has always given back to the community, such as sponsoring the annual Route 66 Rendezvous and the National Orange Show. (Courtesy of author.)

MAYOR AND A GOLD MEDALIST. Mayor Judith Valles is posing with 2001 Winter Olympics Gold medalist and local boy Derek Parra at his homecoming reception in San Bernardino. (Courtesy of Mayor's Office.)

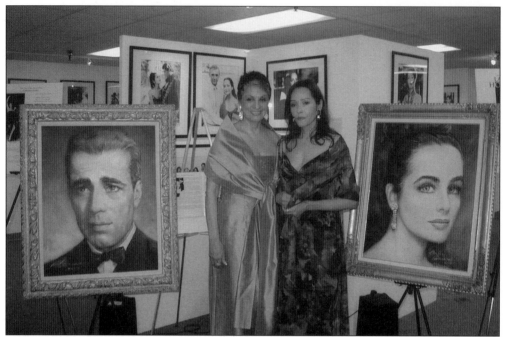

ARTS ON 5TH. Mayor Valles and actress (and former James Bond girl) Barbara Carrera look mighty impressed with the new "Arts on 5th" grand opening in May 2002. (Courtesy of mayor's office.)

RABBI DOUGLAS KOHN. In the long history of Congregation Emanu El, there have been five rabbis. Pictured here is Rabbi Douglas Kohn, the present leader for the Jewish community. (Courtesy of author.)

DOWNTOWN SAN BERNARDINO. This is a shot of downtown San Bernardino on a weekday afternoon in August 2002. The view is looking south on "E" Street from 4th Street. (Courtesy of author.)

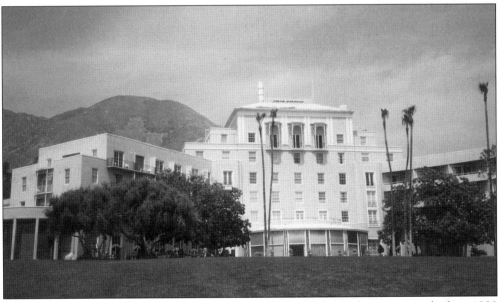

ARROWHEAD SPRINGS HOTEL TODAY. The beautiful hotel that is there now was built in 1939 and is the fourth such structure. The property was bought by Campus Crusade for Christ in 1962 as its international headquarters, and future grandiose plans for the hotel and springs are in the making. At the present time the area is currently closed to the public and will remain so until negotiations with a new owner are completed. (Courtesy of author.)

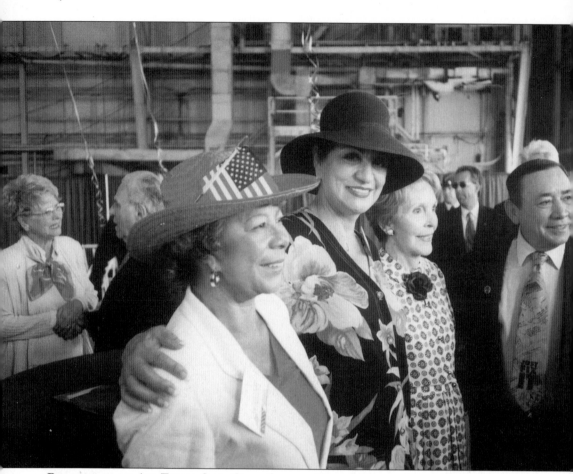

RETIREMENT OF *AIR FORCE ONE*. Councilwoman Betty Anderson, Mayor Valles, former first lady Nancy Reagan, and councilman Joe Suarez attend the retirement ceremony of *Air Force One*, which is now resting at the San Bernardino International Airport. (Courtesy of mayor's office.)